TESTAMENTS IN WOOD

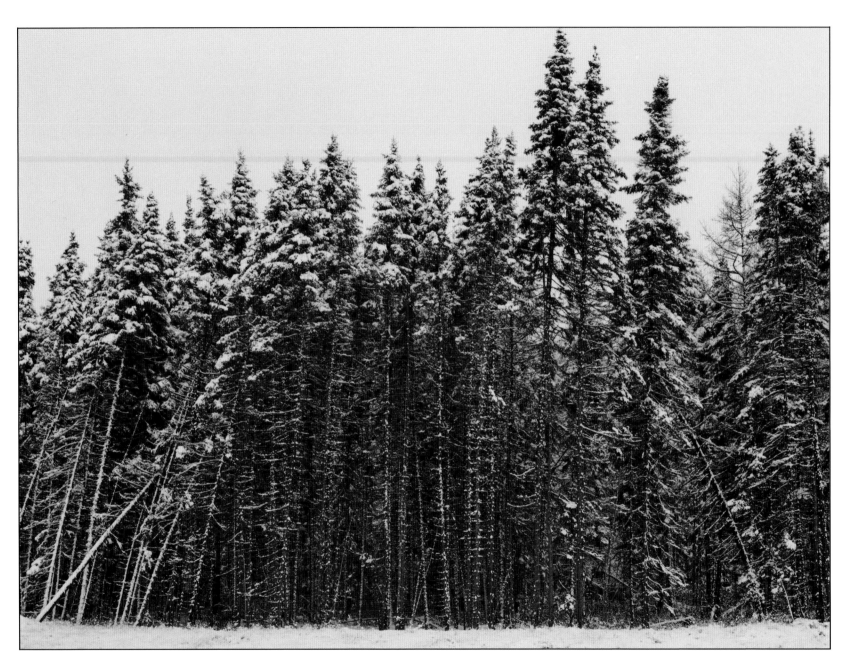

Black spruce and balsam fir trees, part of the boreal forest of northeastern Minnesota

TESTAMENTS IN WOOD

Finnish Log Structures at Embarrass, Minnesota

Photographs by Wayne Gudmundson

Text by Suzanne Winckler

Minnesota Historical Society Press ■ St. Paul

Cover: A stable on the farm of Mikko and Anna Pyhala, Embarrass Township

This book was published in cooperation with Sisu Heritage, Inc., Embarrass, Minnesota, with funds provided by the Northeast Minnesota Initiative Fund.

Manufactured in the United States of America
10 9 8 7 6 5 4 3 2 1

This publication is printed on a coated paper manufactured on an acid-free base to ensure its long life.

Library of Congress Cataloging-in-Publication Data

Gudmundson, Wayne.
 Testaments in wood : Finnish log structures at
 Embarrass, Minnesota / photographs by Wayne Gudmundson ;
 text by Suzanne Winckler.
 p. cm.
 Includes bibliographical references.
 ISBN 0-87351-268-5 (paper)
 1. Log cabins – Minnesota – Embarrass. 2. Ethnic
 architecture – Minnesota – Embarrass. 3. Embarrass
 (Minn.) – Buildings, structures, etc. I. Winckler,
 Suzanne. II. Title.
 NA7235.M62E454 1991
 720' .9776'77 – dc20 91-16556

Dedicated to Jane Edwards Gudmundson for generously sharing her gifts of time, energy, and insight

CONTENTS

PREFACE

■ We Americans have long been fascinated by the land upon which we live. Vast and still a mystery to most of its people even midway through the nineteenth century, the North American continent continues to provide a locus for our dreams of wilderness, adventure, and opportunity. Landscape, unlike wilderness, includes the evidence of the people who have lived there, and each of us encounters and responds to the occupied and evolving landscape in an individual way.

For six years, beginning in 1981, I traveled North Dakota's grid of gravel township roads in one-mile increments, scouring the unbelievably open landscape for signs of perseverance in the face of a hostile climate and extreme remoteness. I photographed headstones and fieldstones, oil rigs and grain elevators, hoping to derive meaning from this visual meandering. The records of my North Dakota travels were published in 1987 in the book *A Long Way to See.*

After this work was completed I got a call from a friend, Eric Paddock, asking me to photograph Finnish-American log buildings at Embarrass, Minnesota, and adjoining townships for a project called "America's Uncommon Places: The Blessings of Liberty." The idea of photographing specific buildings within two or three townships over the course of a few months sounded very appealing. I agreed.

I met Margaret Kinnunen, Embarrass town clerk, and other representatives from Sisu Heritage, Inc., the local Finnish-American cultural organization, at the Four Corners Cafe in Embarrass Township. After introductions and lunch they took me on a tour of the log buildings. I remember being drawn to the simple, strong presence of these structures while feeling almost claustrophobic because the density of the trees kept me from seeing the horizon. North Dakota towns are clearly defined, the houses and stores flocking closely around the ever-present grain elevator. But the physical town of Embarrass is virtually invisible. Homes and farmsteads dot the green coniferous sea like islands.

I gradually became aware of the significance that these log homes and barns held for the people of Embarrass. Facing an economic decline, the town had become inspired in recent years by the very presence of the buildings, renewing a spirit of gritty optimism like the one that guided the Finns who first homesteaded there. Even after finishing the work for "America's Uncommon Places," I returned time and again to Embarrass with my camera. There always seemed to be one more sauna around the corner, another hay barn in the next meadow.

By itself, the richness of the subject matter seemed to justify more study. Talking with Michael H. Koop, historic preservation consultant, I learned more about the buildings and the details of their construction. We began to think about putting together a book. By this time Michael was finishing fieldwork in the Embarrass area and was writing an application to place some of the outstanding buildings on the National Register of Historic Places.

Through a mutual friend I became aware of the work of writer Suzanne Winckler, who had just purchased a farm in Embarrass. I introduced Suzanne to many of her new neighbors, and we shared observations about the area for which we had a great affinity. She accepted the challenge to

write an essay for the book. Eric Paddock agreed to write the introduction, and he also helped to select the photographs that are included in this book. The Northeast Minnesota Initiative Fund awarded Sisu Heritage a generous grant to assist with publication, and a faculty research grant from Moorhead State University helped to offset the expense of fieldwork.

During the three years I photographed in the Embarrass area, I saw many changes take place in the community. Yet the log structures have remained at the core of the changes. They are more than ruins hidden in the forests. Some are in various stages of decay and many have disappeared, but the great majority are still in use. Sometimes when I stand quietly among them, I am acutely aware of the original inhabitants. My hope, my photographic goal, is to evoke a sense of these places and of the people who lived there – who they were and how they went about their lives.

Sisu is a Finnish word that Embarrass resident Bill Seitaniemi defined as "stubbornness beyond reason." It seems to describe both the Finnish settlers who made the log buildings and the people of Embarrass today. They have adopted these buildings as a symbol of their community and their own tenacity. More than twenty of the structures were placed on the National Register of Historic Places in 1990. To revitalize their area, the people of Embarrass have built a log community center measuring 84 feet by 144 feet. They have also opened a Finnish craft store and renovated a sauna and a log building that is used as a visitor center. Through their efforts to preserve and celebrate these testaments in wood, they are working to preserve and celebrate their own community.

Wayne Gudmundson

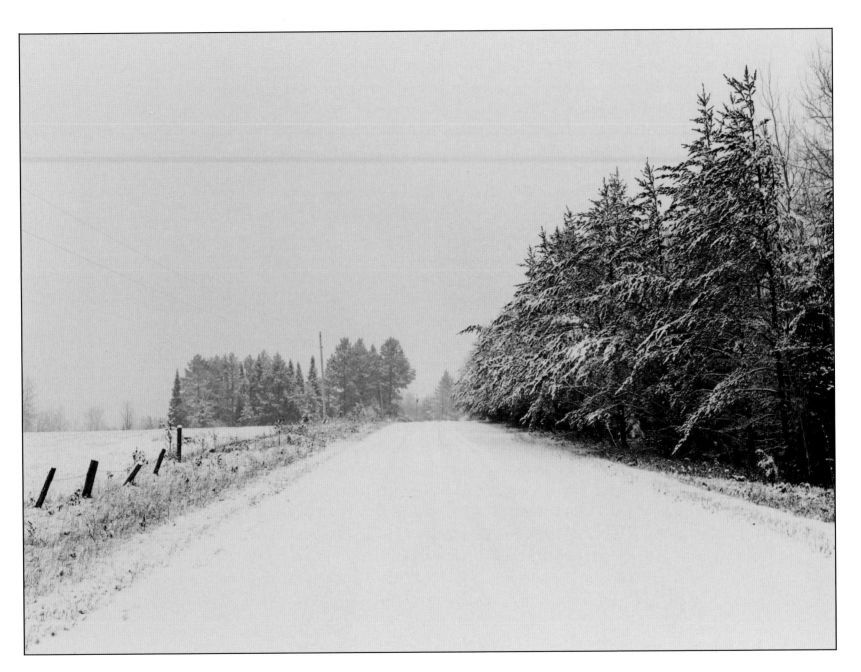

A windbreak of spruce trees bordering a road in Embarrass Township

INTRODUCTION

Awareness of the tangible past . . . comes from a melange of traces, ruins, and artifacts.

– David Lowenthal[1]

■ The Finnish-American farm community of Embarrass Township, in St. Louis County, Minnesota, is an example of the richness and diversity of America's cultural landscape – one that has been shaped by the adaptation of traditional forms to the natural and economic contingencies of the New World. Finnish settlement of northeastern Minnesota in the late nineteenth and early twentieth centuries affected both the environment and the economy of the region, and Finnish architectural styles from that time are clearly evident in the contemporary landscape. It is the legacy of Minnesota's Finnish settlers – their early architecture and their continuing influence on the landscape of Embarrass – that is the focus of this book.

Wayne Gudmundson's photographs, taken in Embarrass and neighboring Waasa and Pike townships, are the outgrowth of a photographic survey of American landscapes and landmark buildings that was conducted by seventeen photographers and their students in 1987. "America's Uncommon Places: The Blessings of Liberty" was sponsored jointly by the National Trust for Historic Preservation and the Society for Photographic Education. By examining our built environment as a reflection of our cul-

tural heritage, the survey extended the long and fruitful relationship between photography and historic preservation.[2]

Because the exhibition that resulted from the survey coincided with the bicentennial of the United States Constitution, project designers selected sixteen sites that reflected some of the historical events and civil liberties that the Constitution has fostered in the past two hundred years. In addition to James Madison's home at Montpelier, Virginia, and Philadelphia's Independence Hall, which are tied to the history of the Constitution, the sites represented the nation's regional, ethnic, and racial diversity through a sampling of residential, industrial, agricultural, and public architecture. Touro Synagogue in Newport, Rhode Island, the oldest synagogue in the United States, was chosen as a symbol of the religious freedoms guaranteed by the Constitution. Other sites, like the Columbia River Highway in Oregon and Washington, put forward the notion that important historical ideas often are embodied in large, regional landscapes as well as in individual structures.

Embarrass was chosen as one of the nation's "uncommon places" because it is an unusual and significant historic site that reflects the ethnic diversity of the American people. The buildings and farmsteads of the township are scattered over a comparatively large area, yet they form one of America's most conspicuous collections of log buildings associated with a single ethnic group. The concentration of these structures in St. Louis County – and especially in Embarrass – is the tangible product of Finnish immigration to the region beginning in the 1880s, when Finns were attracted by jobs in the iron mines and the lumber industry. Many of the structures in Embarrass were built between 1890 and 1930 as settlers established farms on cutover forest lands. The log-walled houses, barns, sheds, and saunas of Embarrass reflect the adaptation of traditional Finn-

ish forms dating from as early as the Middle Ages to the climate, materials, and agriculture of northeastern Minnesota.

Many changes have taken place in Embarrass in the decades since these farmsteads were built. The arrival of public utilities and the improvement of roads into the area shifted the local culture from one that was largely insular and self-reliant to one with more direct links to regional population centers. Development of tourism and service industries in northern Minnesota further removed Embarrass from its farm economy. Above all, in the same way that earlier immigrants were assimilated to American culture at the beginning of the century, their descendants abandoned many traditions as they developed their unique cultural identity as Finnish Americans. The adoption of building materials and techniques that are not in the Finnish tradition – from balloon-frame construction to aluminum siding and fluorescent signs – has added new forms to the fabric of the landscape.

It is not easy to create photographs that express the historical and contemporary relationships between the people of Embarrass and the land of northern Minnesota. To reach a full appreciation of the historical aspects of a place, we would expect to embark on substantial research. For the photographer, however, comprehension is not so much a matter of book learning as a visual discipline that requires the careful observation and orchestration of visible facts. A single building in Embarrass might speak volumes to the alert and sensitive viewer about the building itself and about the people who dreamed, built, and used it.

■ Photography's descriptive power has shaped our understanding of architecture and the landscape since its first public demonstration in Paris by Louis-Jacques-Mandé Daguerre in 1839. The long exposures required by the earliest photographic processes made architecture a likely subject, if

for no other reason than because a building held still for the several minutes that were needed to form a clear image. Perhaps the earliest photographic campaign to produce a planned record of architecture was France's Heliographic Mission, which, beginning in 1851, documented the crumbling churches, mills, bridges, and castles that were slated for demolition or restoration in accord with Napoleon III's grand plan to preserve and modernize the nation.

At about the same time, European imperialism spurred popular interest in the sights to be seen in colonized lands. Along with photographs of far-off scenery and exotic peoples, colonial photographers produced views of antiquities and indigenous architecture that were popular with a wide audience back home. Photographers in European cities marketed their images of local scenery, antiquities, and architecture to tourists or to students of architecture and the arts.[3]

Many of these photographers produced architectural views of unembroidered clarity. Because their work hewed to the facts and offered direct, apparently faithful representations of their subjects – and because they knew their audiences – their work was sought after by architects and art historians. Such photographs are often valued as works of high photographic art, but the photographer's first goal was to illustrate the nominal subject – and the images do that with such humble assurance that the hand of the artist is not always immediately recognizable in stylistic terms. The sense that the photographer is an anonymous witness to a scene, who records it generously but without editorial or emotional affectation, is a quality that is still highly valued in photographic documentation of architectural subjects.

In the United States, photographers of this period had no classical antiquities or biblical monuments on which to focus their attention. They photographed the Indian pueblos and prehistoric ruins of the Southwest in

much the same way that their European counterparts recorded the cities and antiquities of Africa and Asia – as exotic places that stimulated the romantic imagination. On the whole, however, Americans were fascinated with progress; they valued contemporary subjects, celebrated what was new, and proposed that new things become the historical monuments of the future.

Civil War photographers made spare but moving photographs of the battlefields, bridges, cities, and towns that figured prominently in the headlines of the day. These photographic veterans of the war shaped a terse, literary style of landscape photography that was especially suited to the description of landscape history as a process. Photographs of wartime feats of engineering like bridges and earthworks often foreshadow the western railroad photographs of the next generation. Implicit in both kinds of photographs was the idea that nature was a force to be tamed, or perhaps subdued like a battlefield enemy, and that the civilizing force was essentially right and good.

William Henry Jackson was among the best-known American landscape photographers of the late nineteenth century. In addition to views of natural landscapes – the wonders of Yellowstone and the Colorado Rockies, for example – Jackson and his camera operators photographed the cities and towns of the West. The hallmarks of Jackson's grand-style architectural and landscape photography eventually penetrated to the humblest American towns as local photographers diversified their practices to include views of houses, businesses, and livestock as well as portraits and scenery. The advent of American postcard publishing at the turn of the century led to the proliferation of images that were used to boost tourism, investment, and immigration.[4]

Walker Evans, renowned for his images of rural life during the Great Depression, recognized the emotive power of the work of earlier pho-

tographers who allowed their subjects to reveal meaning without heavy-handed editorial tampering; he also admired the directness of commercial photographs and picture postcards. In his architectural photographs Evans forged a plain modernist style in which the everyday landmarks of the United States assumed new metaphorical significance. He chose the most commonplace artifacts of American culture as his subjects – from billboards and shopwindows to vernacular buildings and factories – and developed from them a visual vocabulary that articulated his sense of American life. American landscape photography in recent years has refined and inflected Evans's approach and has been concerned chiefly with the common cultural landscape rather than with picturesque views of natural scenery. Specific subjects range from icons of American life and commerce (grain elevators and farmsteads) to reflections of the general condition of contemporary life (suburban tracts, interstate highway corridors, industrial parks). By turning their attention to the ubiquitous landscapes that Americans inhabit on a daily basis, many contemporary photographers assert their belief that – for better or worse – such vistas embody the thrust of American culture.[5]

■ Wayne Gudmundson has photographed the buildings and farms, roads and forests of Embarrass with the care and grace of one whose respect for the world and faith in the descriptive power of photography allow him fully to trust his subjects. Because his plain, unpretentious style lets the places and things in his pictures speak forcefully for themselves, his pictures seem most expressive when they are most factual.

For example, in a barn Gudmundson discovers both an architectural icon and a rich series of narrative circumstances (page 69). The log barn stands in the center of a meadow of cleared land that presumably yields the forage that is stored inside. One senses the warmth of spring sunlight and

the hint of a gusting breeze. In the foreground, in a space that has been prepared for vegetable gardening, a handful of tomato sets has just been planted; they are protected from cool nights by rings of paper, and a trowel and enamelware pan sit beside them as if just put down a moment ago. The elegant lines and apparent age of the barn suggest that it is old and that it has aged gracefully. But the barn slouches slightly to the left, and the twin poles that brace the roof – which may well have been part of the original structure – seem to prop things up in defiance of gravity. The simplicity of Gudmundson's picture allows us to read these details at our leisure and to make of them what we will. The overwhelming sense of the picture is one of a springtime ritual carried out against the backdrops of ancient tradition and unchanging natural cycles; this sweetly summarizes a vital aspect of life in Embarrass.

Although seasonal cycles shape life in Embarrass, the people who live there answer to the weather in their own ways. In a photograph of a farmstead we again see the flat, cleared land framed by dense forest (page 51). Within the clearing is a cluster of buildings: two low and apparently early log structures at the far left, a corrugated metal hut with a few small windows and a barn door, and a two-story white house, tightly built, immaculately clean, the windows sealed against the cold winter. The successive stages of the farmstead's growth have brought refinements and adaptations, evidence that the land has been carefully tended by people who are devoted to the homeplace.

Attachment to a particular place shapes one's way of seeing things, both at home and abroad. A white painted building – this one a sauna – may be so familiar to its owners and their neighbors that they never give it a second thought (page 58). But perhaps someone will look at it once in a while and appreciate its purpose or its age or its history and will feel a sense of connection or nostalgia. Gudmundson manages to suggest such

feelings of rootedness in his picture – maybe it is the shadows on the snow, or just the friendliness of the structure – even as he clearly describes the size, the proportions, the style, the materials, and the building techniques. This careful balance of fact and aspect, of restraint and affection, is among the great virtues of Gudmundson's work because it allows both a purely descriptive reading and one that is attentive to the human aspects of the landscape.

Gudmundson believes in cultural geographer Peirce F. Lewis's maxim that the "common workaday landscape . . . has a great deal to say about the United States as a country and Americans as people."[6] Through his curiosity about the world, his respect for traditional photography, and his great fondness for the Upper Midwest, he has created pictures that convince us of the importance of Embarrass as a historic site and of the distinctive character of northern Minnesota and its people.

The photographs in this book integrate the functional and aesthetic aspects of the landscape. Gudmundson's work invites us to experience the beauty and ingenuity of individual log buildings while evoking our appreciation of the community's beginnings and the value of architectural landmarks as reminders of our cultural identity. Yet the log structures of Embarrass are not disembodied relics that testify to a remote and unfamiliar past; most are still used in the course of everyday life, and Gudmundson's photographs seek to understand how the landscape of Embarrass shapes – and is shaped by – the lives of the people who live there.

NOTES

1. "Age and Artifact: Dilemmas of Appreciation," in *The Interpretation of Ordinary Landscapes: Geographical Essays*, ed. D. W. Meinig (New York: Oxford University Press, 1979), 124.

2. Sixty-four photographs were included in the traveling exhibition that opened at the Sumner School, Washington, D.C., in October 1987. In September 1988 the Heritage Hjemkomst Interpretive Center, Moorhead, Minnesota, opened a comprehensive exhibition of photographs of Embarrass by Gudmundson and others in conjunction with its venue of the traveling exhibition. For a description of the survey, see J. Jackson Walter, Introduction, and Eric Paddock, "The Photographic Project," in *America's Uncommon Places: The Blessings of Liberty* (unpaginated exhibition catalog, 1987; also published by the Society of Photographic Education as issue 25:3 of *exposure*).

3. Naomi Rosenblum, *A World History of Photography* (New York: Abbeville Press, 1984), 99–100.

4. For a comprehensive discussion of American urban photography, see Peter B. Hales, *Silver Cities: The Photography of American Urbanization, 1839–1915* (Philadelphia: Temple University Press, 1984).

5. Andy Grundberg, *Crisis of the Real: Writings on Photography, 1974–1989* (New York: Aperture, 1990), 66–70; John Szarkowski, Introduction to *Walker Evans* (New York: Museum of Modern Art, 1971).

6. "Axioms for Reading the Landscape: Some Guides to the American Scene," in *Interpretation of Ordinary Landscapes*, ed. Meinig, 12.

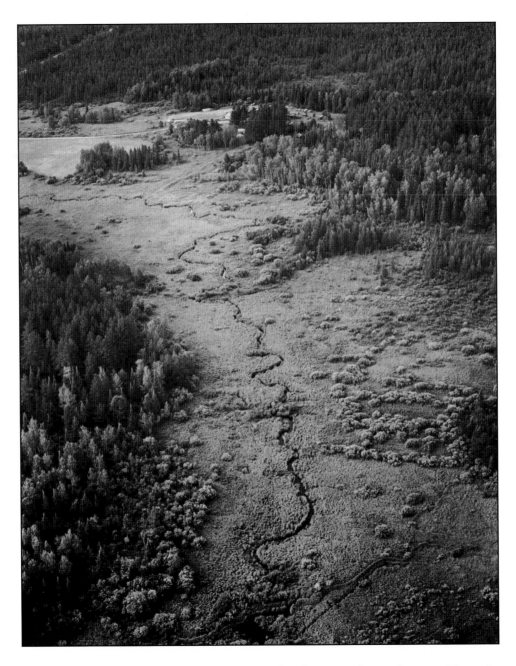

The Embarrass River winding through a landscape of marshes and forests

BUILDERS OF SKILL AND GRACE: THE FINNISH LEGACY

Suzanne Winckler

Migration is a phenomenon that resembles water flowing from the hills: a mighty current formed from thousands of small streams . . .

– Vilho Niitemaa[1]

This one's dead, and this one.

–Sulo Esala, looking at old photograph of Finnish-American choir in Sandy Township, Minnesota[2]

■ In the 1880s and 1890s Finnish immigrants began to move in significant numbers into northeastern Minnesota. This remote and chilly corner of America bore a striking resemblance to their native Finland. But those particulars of landscape and climate, while doubtless comforting to the newcomers, were not inducements enough. What drew the majority of them – what provokes masses of people to pull up roots and move – was the prospect of work.

In this case, the promise was jobs in the newly opened mines of the Vermilion and Mesabi iron ranges, which began shipping ore in 1884 and 1892, respectively. Many of the Finns came to northeastern Minnesota by way of the copper and iron mines on the Upper Peninsula of Michigan, but, increasingly, others arrived directly from Finland. By 1905 some twelve

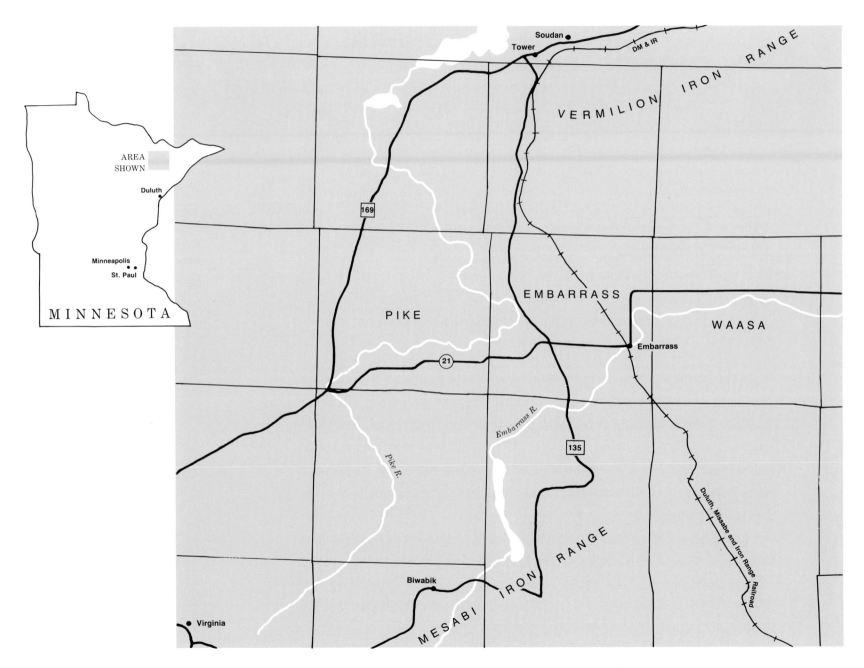

Embarrass and adjoining townships in central St. Louis County, Minnesota

thousand Finns were living in St. Louis County; in 1920 their numbers peaked at about seventeen thousand.

The lumber industry also provided jobs, at least in the winter, and some Finns worked in logging camps or at sawmills. Other Finns acquired land under the provisions of the Homestead Act, or bought acreage from the railroad, and settled down to farm the lands left behind by loggers who had cut down the massive pines – a growing expanse of northern Minnesota that came to be known as the cutover. And, in due time, many of those Finns who had gone first to labor in the iron mines left their jobs and likewise scattered out to farm in the back country.

These lands proved to be marginal for farming. An 1882 surveyor reported that swamps filled much of the low-lying land in Embarrass Township, St. Louis County, and that the uplands were strewn with "coarse granite boulders of all sizes and shapes"; moreover, the soil was "generally third rate." After logging, the land included pockets of spruce and fir trees, with aspen and birch and a heavy covering of brush growing quickly to fill the spaces on the higher ground where the big trees had stood.[3]

These defects did not seem to daunt the Finns. On the contrary, they seemed almost inspired by life on the societal and economic fringe. From their quiet triumph in this hinterland one can draw a broad inference about Finnish immigrants in America. They are wizards of invention and masters of parsimony.

■ The Embarrass River begins to appear in the written historical record in the 1820s. *Embarras* is a French word meaning encumbrance or hindrance. French explorers and fur traders applied the term throughout the Great Lakes region to narrows or bottlenecks on waterways – places where snags impeded travel or where canoes had to be portaged for a distance overland. While Embarrass would become distinctly Finnish after

1900, its name preserves an aspect of the roving French voyageur culture that came before, and stands in sharp contrast to, the more sedentary customs of the Finns.

Finns began to settle near the Embarrass River after 1892, when the Duluth and Iron Range Railroad opened a depot there on its line running north from the shore of Lake Superior. Cutting logs of pine, tamarack, spruce, and other trees, the newcomers built homesteads according to Old World schemes. A number of their habitations – the proud and solemn subjects of this book – remain in Embarrass and the neighboring townships of Waasa and Pike. They are sturdy but elegant, humble yet patrician, and they lend to the back roads of northern Minnesota a remarkable countenance. There is something quite sovereign about these places – each its own kingdom – and while it can be perilous to extract too much meaning from panoramas, the Finnish farmsteads stand like the last echoes of autonomous lives discharged with thrift and grace.

One of these places is the Matt and Emma Hill farmstead in Pike Township. It stands on a bluff overlooking the Pike River, a stream that winds through the forests and bogs that distinguish far northern Minnesota. Hill, a Finnish immigrant, applied for his 160-acre homestead on August 4, 1897. By about 1903 the Hill family had cultivated 5 acres of arable land out of 16 acres that the final homestead proof called "timbered agricultural land." The family was also completing work on the primary buildings of the farm, the *savusauna*, *tupa*, *navetta*, and *lato*. This assemblage – the smoke sauna, house, cattle barn, and hay barn, respectively – forms the classic quartet of the rural Finnish farmstead as composed at the turn of the century on American soil.

In the characteristic Finnish manner, these buildings stand in loose alliance. Apart yet together, they create the vague effect of a courtyard. They dance at arm's length. The explanation for this arrangement is obvious and

practical: if one building goes up in flames it will not take along its partners. Yet this spatial affiliation – standing together while keeping a distance – also serves as an emblem of what seems to be a clear and poignant Finnish trait. For Finns have a way of dancing at arm's length, with one another and the rest of the world. They manifest quiet reserve without utter detachment.

A visitor who comes into the Hill place on the path from the north will scale a gentle slope and notice first the cattle barn (page 59) and then the house (page 61), which stands shyly behind an almost oriental screen of aspen. One story with a loft, the cattle barn is a large, squarish building, twenty-four feet by twenty-five feet. It is built of stout timbers hewn into planks with a broadax and secured at the corners with double-notched joints. The cattle barn is listing with age and its loft has collapsed, but it still bears the signs of splendor that characterize utilitarian structures well made.

By comparison, the house has not shifted a degree off the vertical. Its ramrod posture at this late date is a result of the drop siding and corner boards that cover the original log structure. Drop siding is machine-milled lumber fashioned so that each board fits snugly with its partner; corner boards are milled lumber used to box in the protruding joints of a log structure. Drop siding and corner boards give a roughhewn structure a tidy appearance, and Matt Hill perhaps added them to modernize his log home. Whatever its intent, the siding has shielded the original hewn timbers and their joints from the elements and thus from collapse.

Behind the cattle barn to the north stands an eleven-by-eleven-foot log building. Its blackened interior walls strongly suggest that it was the original smoke sauna. This traditional steambath was heated by a wood fire hours before use. The smoke from the fire that built up in the snug building was released by a small vent prior to bathing but nonetheless blackened

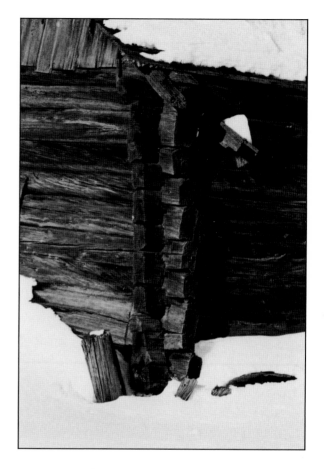

Double-notched joints

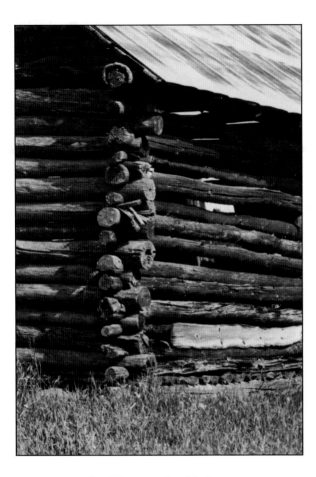
Saddle-notched joints

the walls. At some point – perhaps when the sauna that stands to the west was built – the smoke sauna was converted to a diminutive two-stall livestock stable. The newer sauna (page 58), dating from about 1920, is part log (the bathing room) and part frame (the dressing room) and is sheathed entirely in drop siding. This sauna did not employ the smoke method. Instead, a wood stove, vented to the outside, heated a pile of rocks atop the stove. The bathers threw water on the rocks to create waves of steam.

The hay barn, and a structure that was perhaps an animal barn (page 60) – both now ravaged by time and weather – lie in two heaps to the southeast of the house. While the sauna is the heart and hallmark structure of the Finnish homestead, the hay barn represents a New World vestige of medieval agrarian practices, for Finnish farmers in Europe were storing hay in barns of this design by the early fifteenth century. A hay barn is built with unhewn logs joined at the corners with saddle notches and purposefully gapped to allow ample air circulation for drying the hay. It is sometimes attached to the cattle barn, sometimes freestanding within the farmstead court, and sometimes erected far afield from the farmyard. A freestanding hay barn often has sides that slant inward at the foundation, a configuration that encourages the flow of air. The hay barn is perhaps the most peculiar looking of all the Finnish-American structures; it is also something of a digression in the vernacular repertoire since, under most circumstances, the point was to keep air out, not let it in.

The Finns who cleared farmsteads in northern Minnesota in the early twentieth century carried with them a two-thousand-year-old method of log construction that was admirably suited for the latitudes in which the immigrants settled in the New World. The Great Lakes region was not the first part of North America to see Finnish log construction, however. It was introduced in 1638 by Finnish settlers in the short-lived colony of New Sweden, along the Delaware River in what would be the states of Pennsyl-

vania and Delaware. Although log construction changed in Finland during the 250 years between that early colony and the movement of Finns to northern Minnesota, the buildings in Embarrass are part of a continuing adaptation of old northern European forms to new places and materials.

Matt Hill and his neighbors constructed their cattle barns, houses, and saunas in this northern European method. The procedure created airtight buildings that kept the cold out and the warmth in, and the resulting structures are distinguished by the tight fit of their scribed timbers. The builder used a *vara*, or double-pointed scribe, to trace the contour from the top of one log to the belly of the log that was to rest atop it. He then hewed the scribed log so that it would fit snugly against its mate and conform with any of its idiosyncrasies. Frequently the builder carved a longitudinal groove in the underside of each log and filled this furrow with moss to achieve extra insulation. Using a broadax, he then planed the interior and exterior sides of the timbers and secured the corners with double-notched or fully dovetailed joints. The planked timbers of Matt Hill's cattle barn and house fit one on the other like strata in a geologic formation, the surviving proof of the maker's patience and skill.

■ Deciding to pull up stakes is a matter of comparing a knowable present with an imagined future. These are the "push-pull" catalysts – the push of the mother country and the pull of the receiving country. Like most immigrants, Finns came to America because circumstances in their homeland were difficult, if not intolerable, and because the future in a new place promised to be brighter, freer, and more prosperous.

Finland, wedged between Sweden and Russia, was for hundreds of years under the thumb of one or the other of these neighbors, and for hundreds of years its citizens preserved the Finnish language and a sense of identity amid cultures to which, at least linguistically, they did not be-

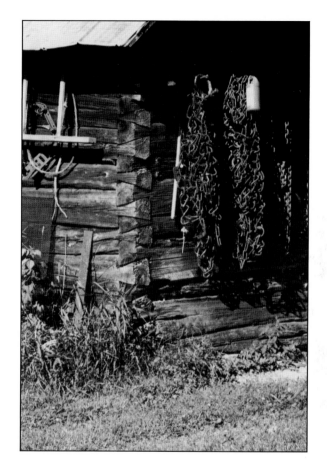

Dovetailed joints

long. Finnish is related neither to the Scandinavian languages nor to Russian. It is part of the Finno-Ugric branch of the Uralic language family and is allied to Estonian, Lappish, and Hungarian. The original homeland of the Finns is thought to be the forests and steppes between the middle Volga River and the Ural Mountains.

Sweden ruled Finland for six hundred years, from about the middle of the twelfth century until 1809, when, as a result of the Napoleonic Wars, Finland became a quasi-independent grand duchy of Russia. During the long dominance by Sweden, Swedish served as the language of the educated classes. If the Finnish language was not the endorsed one, it was fortunately protected and standardized by religious leaders in their effort to spread Lutheranism during the sixteenth century.

Finland enjoyed more autonomy as a grand duchy of Russia, and the years after 1809 were marked by a growth in national pride and cultural esteem. In 1835 the *Kalevala*, an epic collection of Finnish folk tales and poetry, was published, and in 1863 Finnish became the official language. Nonetheless, the nineteenth century was grim in many respects in the grand duchy of Finland, especially for landless workers. It was during this time that their exodus to America began, despite warnings and chidings from the upper-class establishment and the Lutheran state church.

The migration from Finland was rooted in the Malthusian equation of that era. Across the European continent, the nineteenth-century population explosion outpaced food production and the region's nascent industrial capacity. There were more farmers than land to farm and more workers than jobs. Finland's population, for instance, grew from 1 million to 2.7 million between 1811 and 1900. The people suffered waves of famine in midcentury. In the worst, which struck in 1867–68, tens of thousands died of starvation.

Finns began to migrate from the countryside to Helsinki, their capital,

to other Finnish towns, to Sweden, where they found work in the timber industry, or to Norway to work as miners or fishermen. Both of these countries served rather like staging grounds for many Finns, who eventually moved on to the United States. As conditions continued to deteriorate at home, word of America – the promised land – began to beckon a populace that was strapped, weary, and politically oppressed.

At the same time, America's industries (voracious for laborers), its railroad companies (eager to sell the millions of acres of land they had acquired for building trackage), and European shipping lines (hawking passage on their vessels) kept migrants' fevers running high with exaggerated reports of the American haven. Although no official emigration records were kept in Finland before 1883, scholars estimate that from seven thousand to fifteen thousand Finns left the Old World between 1865 and 1882.

In 1881 Czar Alexander II, who was held in high regard by many Finns, was assassinated by Russian revolutionaries. This event marked the end of Finland's amicable relationship with Russia. Successive Russian overlords would not display the same benevolence toward the Finnish duchy. Alexander III's reign (1881–94) was distinguished by what historian Hans R. Wasastjerna described as a widespread "oppression of all minority nationalities."[4] This trend continued under the next czar, Nicholas II, and reached a crisis with the February Manifesto of 1899, which eliminated or altered many of the freedoms Finland had gained.

Combined with a bleak economy, this darkening political situation would ultimately push Finland to independence in 1917, but its most immediate effect was to accelerate the departure of Finns for America. The most abhorrent aspect of the new policy was the illegal conscription of Finnish men into the Russian army, a grim prospect that provided the final nudge for many Finns to leave. About twelve thousand Finns left their

country in 1899, a flight that peaked in 1902 when twenty-three thousand people emigrated to other countries.

The pain and confusion of leaving one's homeland, combined with the stigma of fleeing a draft – even an illegal one – could still be sensed among Finns in and around Embarrass many decades after the issue of Russian conscription had prodded their kin to leave for America. Longtime Embarrass resident George Warho left Finland with his family in 1906 when he was seven years old. In 1983, at the age of eighty-four, he hedged when asked by an oral history interviewer why his father had left Finland. "That's a long story," he said. "I don't think I'll go through the details of it." Then, with some reluctance, he said of his father: "He skipped the country. He was in the draft." Warho pointed out that his father left behind a good job as a metalworker in a foundry to bring his family to an obscure place and unknown future in Minnesota.[5]

■ Alexander and Susanna Palo (shortened from Palokangas) are often cited as the first Finnish homesteaders in Embarrass. They were natives of Kortesjärvi, Finland, who came to the Embarrass area by way of Virginia, Minnesota, where Alexander had been a mine worker. He filed for his homestead in 1898. The Palos and their six children are listed on the 1900 U.S. census for Township 60 Range 15, which was officially organized as Embarrass Township in 1905. Alexander's occupation is listed as farmer. His move out of the mines and onto the land may well have inspired other Finnish laborers to follow suit.

Work in the iron ore mines was exhausting and dangerous, particularly for laborers who occupied the lowest rung of the ethnic totem pole, as did the Finns. Whatever motives Finnish immigrants had for leaving Finland, whatever mental pictures they had formed of a new life in America, the

reality they confronted in the mines and mining towns of the iron ranges fell considerably short of what would pass for a promised land.

Because the majority of them arrived in America after many other European immigrants had established themselves in the workplace, the Finns were left to fill only the most dangerous and lowest paying jobs at the mines. "My first days were a foretaste of hell," a young Finnish miner recalled of his initiation into work in an underground mine. Between 1906 and 1910, 360 workers were killed in iron mining accidents in Minnesota; 102 of those were Finns. In addition, mine bosses held foreigners back in favor of employees who were native-born Americans or Englishmen from Cornwall. Scholars have different interpretations of the purpose of this practice. Cultural geographer Matti E. Kaups viewed it as a standard practice to be expected of all cultures, whereas historian Michael G. Karni saw it as menacing evidence of ethnic discrimination.[6]

In any case, many Finnish miners spoke out about these appalling labor conditions during the Mesabi Range strike of 1907, which primarily involved the Oliver Mining Company. Oliver Mining, a division of United States Steel, was the largest employer on the Mesabi Range. Strikers were asking for an eight-hour workday, a minimum wage of $2.50 a day for open-pit laborers and $3.00 for underground workers, and curtailment of the system of petty bribes paid to foremen to secure better assignments. Oliver Mining dug in its heels, which it could afford to do. It refused to negotiate, it fired three hundred union members outright, and it brought in hundreds of Montenegrin, Croatian, and other southern European immigrants to work in place of the strikers.

Two months later, when the strike was called off, the workers had achieved nothing; if anything, they had lost ground. After the strike, discrimination against Finns as a group became open and strident. Finns had been in the front lines of the protest, and the mining companies were afraid

of the strong Socialist views of some Finnish workers. Oliver Mining blacklisted many Finns, regardless of their political views. In a 1908 survey, mining employers described their Finnish workers in vicious terms: "good laborers but trouble breeders"; "a surly, troublesome lot"; "a race that tries to take advantage of the companies at every opportunity and are not to be trusted."[7]

Compared with the conditions they left behind in the Old World and the hardships of the mining work they performed in the New, farming offered Finns a better way of life. They were able to work in the sunlight and fresh air. They also achieved a degree of autonomy by being able to own and work a fair-sized parcel of land. The average Finnish farmstead in the vicinity of Embarrass before 1920 was 122 acres, remarkably larger than most farms in Finland; because of population pressures, 70 percent of the farmsteads there were smaller than 22 acres by 1901.

Farming the cutover forest lands of northeastern Minnesota proved to be an unusually arduous undertaking. Stumps, rocks, and trees had to be removed; swamps had to be drained. The work was not only backbreaking but also hazardous. Inez Oja, who grew up near Britt, north of Virginia, and later lived with her husband Arvo Saari in Pike Township, told of the day when her father's right eye was put out and the thumb blown off one hand when a dynamite charge he had set to loosen a stump in his field misfired.

Once the land was cleared, the poor quality of the soil limited the choice of crops that the farmer could plant. The potato became the major cash crop of the cutover farm, which also supported hay, oats, rye, and wheat. Embarrass area farmers supplemented their income by selling the timber that they removed from their land—products like sawlogs, pulpwood, and railroad ties. As the number of milk cows increased, dairy products became an important part of the local economy.

On average, a Finnish homesteading family managed to clear only

about an acre and a half of land a year. One exception to this rule – the family of Andrew and Hedvig Saari, Arvo's parents, who were homesteading along the Pike River – cleared 15 acres of land from 1900 to 1905, an impressive 3 acres annually. During that same time, according to the final homestead proof, the Saaris also built a house, a cattle barn, four hay barns, a blacksmith shop, two root cellars, and a sauna (see pages 48–49, 68–69). Andrew Saari had arrived from Finland at the port of Quebec in May 1893, and he probably worked for several years as a miner in the Upper Peninsula of Michigan or in northern Minnesota. Descendants of Andrew and Hedvig were still using the buildings, still farming and haying the fields and meadows of the now 200-acre farm in 1991. There is a deceptive tranquility about the Saari meadows that belies the formidable effort put forth almost a hundred years ago to clear them.

■ The 1900 U.S. census of Township 60 Range 15 tallies the names of forty-nine people. The first name on the list is a Mrs. Lower (her first name is illegible), a twenty-five-year-old widow from Denmark with two children, ages three and one; she ran a boardinghouse for fifteen men. Most of these men were single, young, American-born employees of the railroad. Lyman M. Linnell, age sixty-four, born in Maine, listed his occupation as farmer, but he was also the community's first storekeeper. Of the forty-nine people on the list, twelve were born in Finland, a cluster that included the families of Erick and Lisa Erickson, Frank and Mary Hill, John and Kaisa Paivarinta, and Alexander and Susanna Palo. Others listed their places of birth as Canada, England, Germany, and Scotland.

Early Embarrass, judging from the 1900 census, was an ethnic conglomeration. If anything, the census suggests that the township was peopled not with European immigrants seeking a tentative toehold in a new world but with first- and second-generation Americans moving westward

in pursuit of jobs and land. The year 1900 was a turning point for the settlement, however. In that year, or soon thereafter, Finns began to arrive in the Embarrass area in greater numbers.

Emanuel and Alma Erickson, Mathew and Sophia Hannula, John and Elmiina Kangas, Isaac and Sophia Lamppa, John and Susanna Maki, John and Emilia Nelimark, Samuel and Maria Norha, and John and Lena Salmi, with their children, were among the Finnish families who brought a profound shift in the aspect of Embarrass. In five years Embarrass grew sixfold. But, more important, it became a Finnish enclave. The 1905 Minnesota census enumerated 296 people in the township, of whom 267 – or 90 percent – were born in Finland or in America of Finnish parentage.

Some of the predominantly Finnish townships in northeastern Minnesota – such as Alango, twenty miles north of Virginia – owed their growth to the blacklisting of Finns after the 1907 miners' strike, which not only further disillusioned the immigrant laborers but also left them bereft of employment. Embarrass, however, had become a nucleus of Finnish settlement well before this labor unrest. At least some of its founding citizens – Emanuel Erickson and Isaac Lamppa, for example – had worked in the Michigan mines. Emanuel and Isaac worked for a time in the Mesabi and Vermilion mines before homesteading in Embarrass. Isaac Lamppa also became a lay preacher in the area and served as a minister in the congregation of the Finnish Apostolic Lutheran church that was established in Embarrass in 1906.

Apostolic Lutherans were also known as Laestadians for Lars Levi Laestadius, the Swedish leader of a pietistic revival in northern Scandinavia in the mid-nineteenth century. His followers in Finland veered from the formalistic theology of the Lutheran state church and moved toward a doctrine that encouraged preaching by lay members of the church. Apostolic Lutherans were among the first Finns to leave the Michigan mines in the

late nineteenth century. They were motivated to move because of conflict with representatives of the traditional Finnish church, unreliable employment in the mines, and the availability of homestead lands in places like Minnesota.

Perhaps most important for understanding the tenor of the future township of Embarrass, the Apostolic Lutheran church preached the virtue of the temperate, agrarian life. Board members and trustees of the Embarrass church included several of the township's early settlers, among them Isaac Lamppa, John Nelimark, John Paivarinta, and Alexander Palo. The Laestadian sanctuary, a small, white frame structure built in 1906, sits on the brow of a hill on County Highway 21 a mile and a half east of Four Corners, the intersection of Highway 21 and State Highway 135 (page 40).

In many ways, the Embarrass of the early twentieth century was a crucible for the diverse, and often opposing, array of Finnish beliefs. Historically Finns have placed great emphasis on reading and on the education of both men and women; consequently, Finns brim with opinions. In these early years, Finnish Americans in northern Minnesota also demonstrated a zeal for organizing clubs and societies that promoted their beliefs. Although Embarrass was convened on a Laestadian bedrock, other views took root as well.

The Laestadians – and other Finns who established churches in the Embarrass area – distinguished themselves from the rival Red Finns, who focused on secular issues, spoke out about the rights of workers, were sometimes members of the Socialist or Communist party, and helped organize the Finnish workers' halls and early cooperatives that sprang up in the townships throughout northeastern Minnesota. Between these poles there were gradations of opinion. One resident of the area remembered that the workers' hall in Ely, for instance, was nicknamed the "pink hall,"

apparently because its membership represented a watered-down version of orthodox Red thought.[8]

An outgrowth of this associative spirit was the consumers' cooperative movement, to which Finns have contributed more than any other immigrant group in America. Early rural Finnish-American cooperatives were pragmatic in purpose – they were organized to circumvent the unfair practices of local merchants. Cooperatives took on more political overtones after the organization in Hibbing in 1906 of the Finnish Socialist Federation (which became the largest foreign-language federation in the Socialist Party of America) and with the labor strife on the Mesabi Range in 1907, when merchants denied credit to striking miners, and again during the bitter strike that erupted in 1916.

Cooperatives came to symbolize the efforts of the underdog immigrant working class to defy the exploitation of the capitalist system. As one Michigan co-op member put it in 1925, "The co-operative store should not be a mere business institution, but should be a factor, a weapon, in the struggle for the emancipation of the working class."[9] In 1929 this political dimension would become an issue of fierce disagreement among the members of many cooperatives throughout the region, as the Workers' (Communist) Party of America tried to turn the wholesale supplier for the cooperatives – the Cooperative Central Exchange in Superior, Wisconsin – into an auxiliary of the party. The outnumbered Communists were defeated in this effort by the more pragmatic element within the cooperative membership. This event was a turning point for Finnish Americans, marking their entry more fully into the American mainstream.

The Embarrass Cooperative Association was organized in 1909. The Embarrass Socialist Hall – also called the Workers', or Red, Hall – was built in 1914, and two years later the Church Finns of Embarrass built the competing Oras Hall, especially for athletic events. *Oras*, the Finnish word

for seedling or sprout, reflected the community's hope of growing its young people in the proper soil. Years later Embarrass residents remembered the Workers' Hall for its Saturday night dances and Oras Hall for the wrestling and other athletic competitions that it sponsored.

By the mid-1910s these three institutions – the Embarrass Cooperative, the Workers' Hall, and Oras Hall – stood within a mile of each other, along with the Hannula store and postoffice (which Hannula had purchased from Linnell in 1905) and the Embarrass railroad depot. This assembly, near the Embarrass River where today's eastbound Highway 21 takes a sharp turn to the north, formed the heart of Embarrass Township. Considering the remoteness of the region from a large urban center, the difficulty of communicating, the rigors of getting from place to place, and the long winters that constrained fraternizing, this gathering place offered a surprising assortment of social, material, and intellectual possibilities to the constituents of Embarrass Township.

■ Steady, irrevocable changes began to take place in Embarrass by the mid-1930s. The Workers' Hall burned down in 1934. Oras Hall was bought by a Lutheran church and converted to other uses. The Embarrass Cooperative closed after fire destroyed the building in 1963. And the Embarrass railroad depot was razed in 1965. Hannula sold his store to Axel and Isaac Lamppa, Jr., in 1928, and the Lamppa grocery and hardware store was still in operation in 1991 (pages 34–35). Standing at the bend of Highway 21, Lamppa's store seems unremarkable in every way – a small, rural emporium where regular customers and random passersby stop to buy things and exchange small talk, mainly about the weather. But Lamppa's provides a lesson in understanding, and savoring, the history that invariably hovers just beneath the surface of seemingly prosaic places. Lamppa's is a rem-

nant gathering spot, a last social and mercantile trace of the Finnish heritage of Embarrass.

There are other places in Embarrass and its neighboring townships where a seeker can find vestiges of this legacy. The sauna of Erick and Kristina Nelimark, located on the eastern boundary of Embarrass Township at the junction of Highway 21 and Salo Road, is an outstanding and well-preserved example of the Finnish bathing tradition. This hewn-log structure measures roughly sixteen feet by twenty-three feet, making it the largest sauna in the area. It was no doubt planned capaciously to accommodate the Nelimarks, their eleven children, and possibly their friends, since it is a Finnish tradition to share sauna with neighbors.

Less than a half mile east on Salo Road, tucked in a dense evergreen grove, is the Mikko and Anna Pyhala farmstead. This quiet, haunting place stands near the top of a hill overlooking open meadows and the meandering Embarrass River to the east. The homestead consists of eight buildings, six of them log structures, built from the late 1890s to the 1940s (pages 62–66). Particularly beautiful is the barn, a building consisting of two log pens joined together to form a passage for wagons. The left pen – built of carefully scribed, hewn logs – housed cattle, while the right pen served as a hay barn, its unhewn logs spaced an inch or so apart to let the air circulate.

On the other side of the township, West Saari Road heads into Pike Township. This road zigzags through a classical Finnish-American landscape of meadows intermingled with boreal forest. Where the road crosses the Pike River, a lone hay barn stands south of the bridge on the east bank of the stream (pages 48–49). Along these back roads the Finnish-American experience is a palpable part of the landscape. In these places you can simply walk across a field or look out over a bend in the river or stand in the utter silence on the edge of the forest and begin to sense what it must have been like to be a stranger making your way in a new world.

NOTES

1. Preface to *The Finnish Experience in the Western Great Lakes Region: New Perspectives*, ed. Michael G. Karni, Matti E. Kaups, Douglas J. Ollila, Jr. (Turku, Finland: Institute for Migration, 1975), vii.

2. Sulo M. Esala, interview by Velma Doby, November 19, 1980, for the Minnesota Finnish-American Family History Project, tape on file at Immigration History Research Center, University of Minnesota, St. Paul.

3. Quoted in Michael H. Koop, "Rural Finnish Log Buildings of St. Louis County, Minnesota, 1890–1930" (Multiple Property Documentation Form, National Park Service, U.S. Department of the Interior, 1988), unpaginated.

4. *History of the Finns in Minnesota* (Duluth, Minn.: Minnesota Finnish-American Historical Society, 1957), 19.

5. George Warho, interview by Tom Rukavina, July 22, 1983, tape on file at Iron Range Research Center, Chisholm, Minn.

6. Michael G. Karni, "The Founding of the Finnish Socialist Federation and the Minnesota Strike of 1907," in *For the Common Good: Finnish Immigrants and the Radical Response to Industrial America*, ed. Michael G. Karni and Douglas J. Ollila, Jr. (Superior, Wis.: Tyomies Society, 1977), 73 (quotation); Don D. Lescohier, *Industrial Accidents and Employers' Liability in Minnesota*, part 2, *Twelfth Biennial Report*, 1909–10, Minnesota Bureau of Labor, Industries and Commerce (The Bureau, [1910]), 209; Matti E. Kaups, "The Finns in the Copper and Iron Ore Mines of the Western Great Lakes Region, 1864–1905: Some Preliminary Observations," in *Finnish Experience in Western Great Lakes*, ed. Karni, Kaups, and Ollila, 63–64; Karni, "Founding of Finnish Socialist Federation," 73–74, 78–80.

7. Quoted in Karni, "Founding of Finnish Socialist Federation," 78–79.

8. Andy Johnson, transcript of interview by Tom Rukavina, August 25, 1983, p. 32, tape and transcript on file at Iron Range Research Center.

9. Quoted in Arnold R. Alanen, "The Development and Distribution of Finnish Consumers' Cooperatives in Michigan, Minnesota and Wisconsin, 1903–1973," in *Finnish Experience in Western Great Lakes*, ed. Karni, Kaups, and Ollila, 116.

PHOTOGRAPHS

Wayne Gudmundson

Entering Embarrass from the west on County Highway 21

The intersection of Highway 21 and West Salo Road

Embarrass businesses along Highway 21 by the crossing of the Duluth, Missabe and Iron Range Railroad

Lamppa's store and a nearby railcar loaded with pulpwood bound for a paper mill

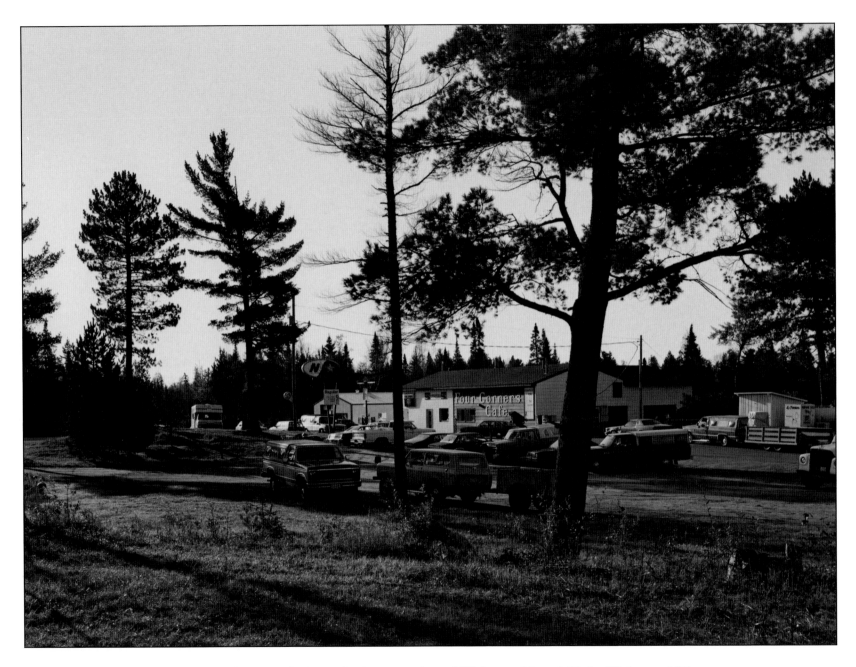

The Four Corners Cafe at the intersection of Highway 21 and State Highway 135

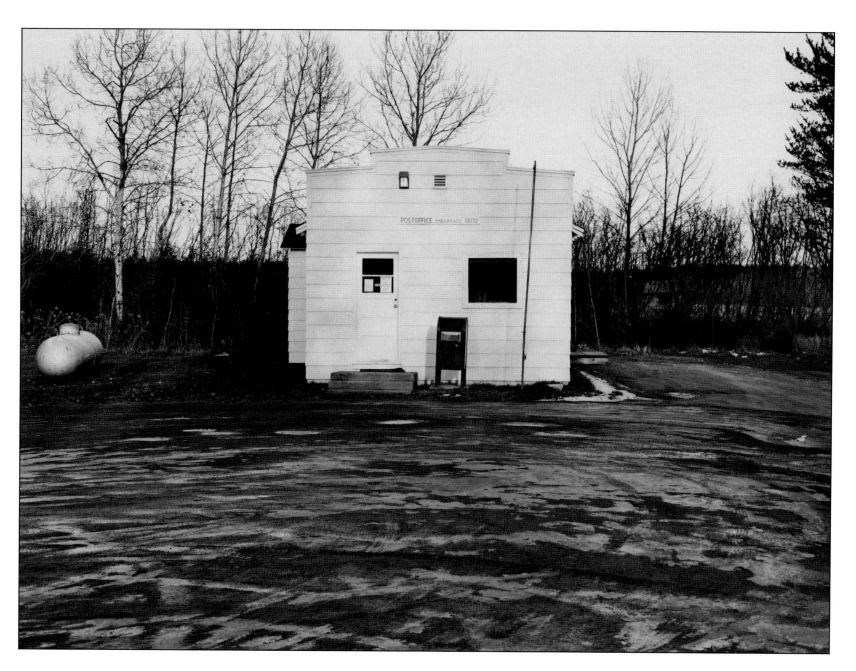

The Embarrass Post Office, located near Lamppa's store

Public tennis courts along Levander Road

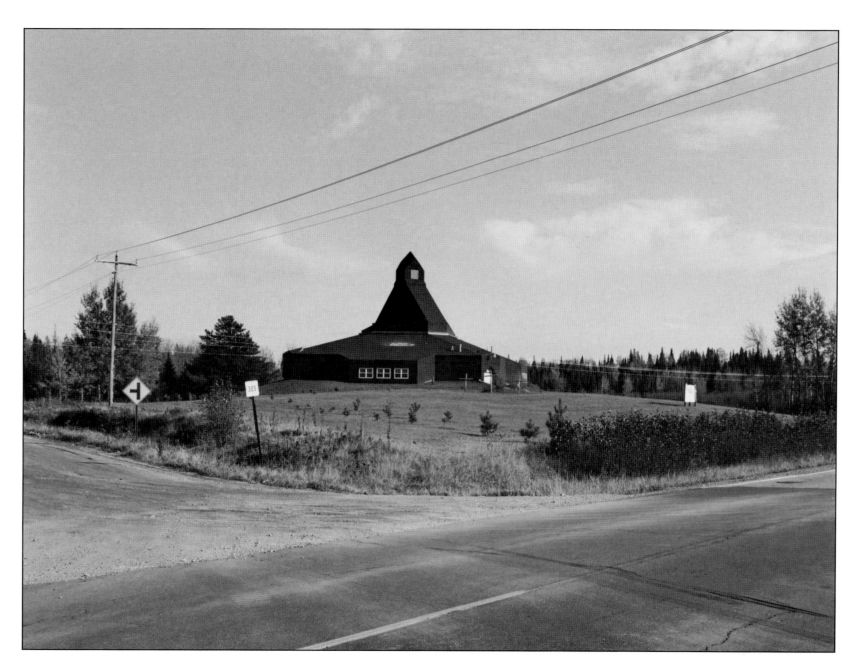

The Embarrass Evangelical Free Church, built in 1983

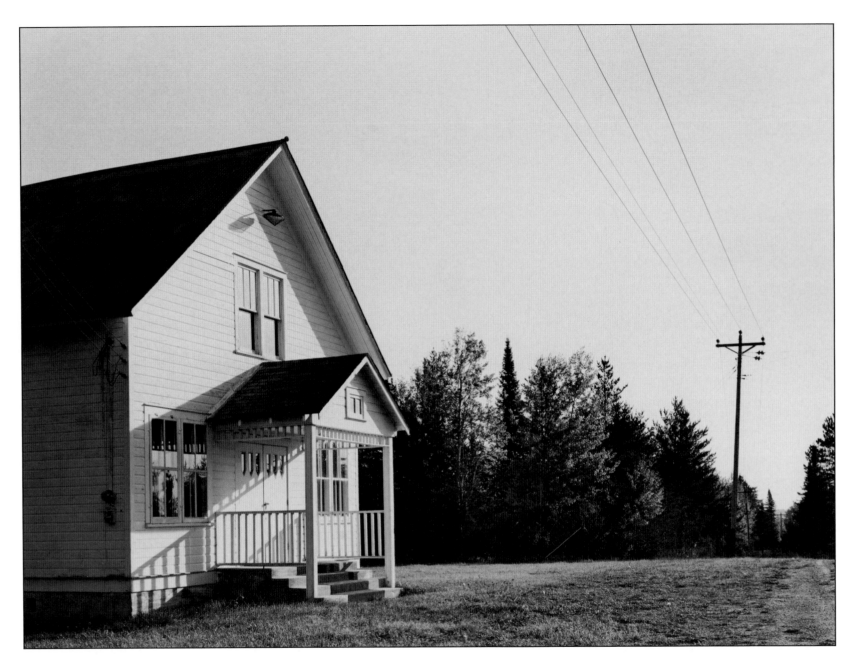

The Embarrass Apostolic Lutheran Church, built about 1906

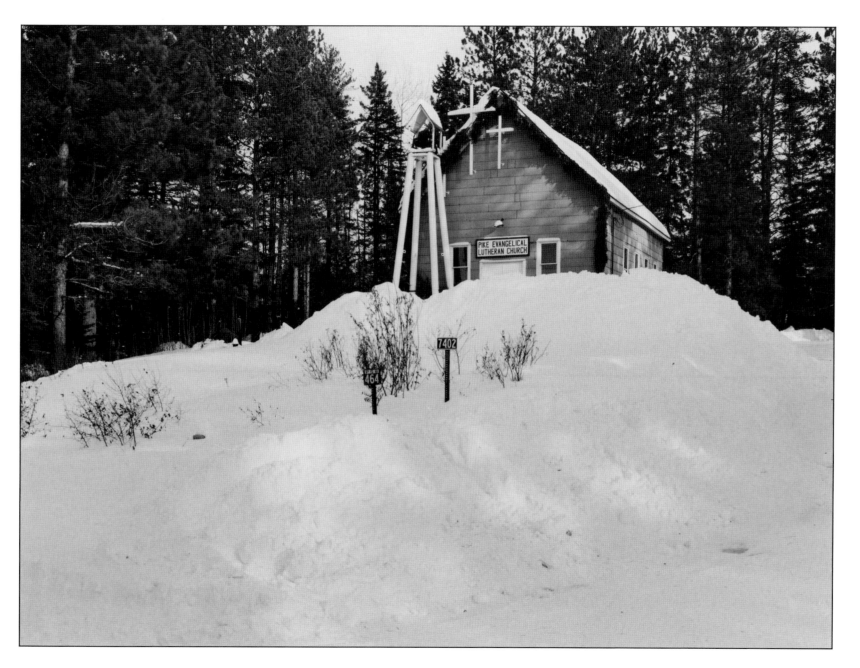

The Pike Evangelical Lutheran Church, Pike Township

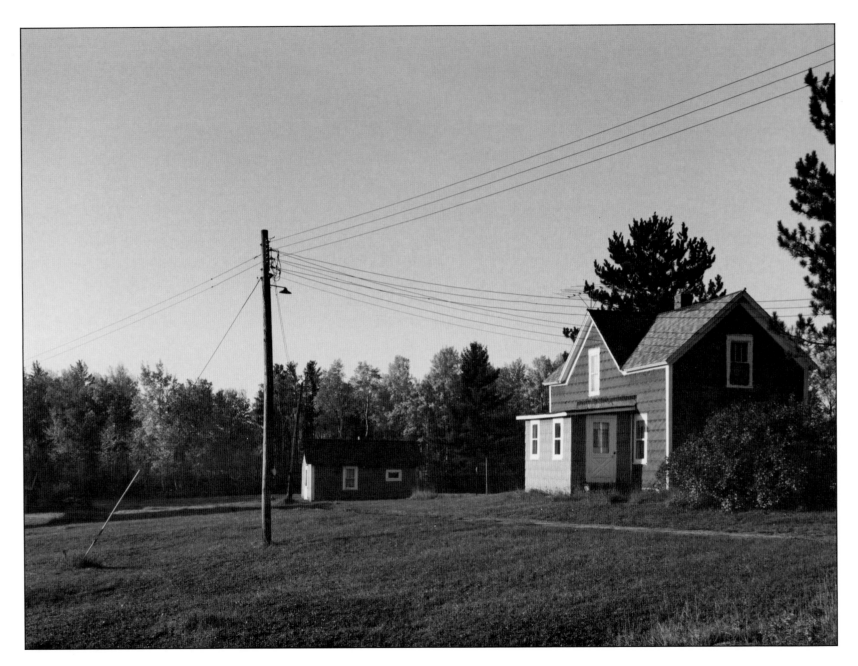

42 The *tupa* or house on the Nikolai Lehto farm, with the sauna in the background

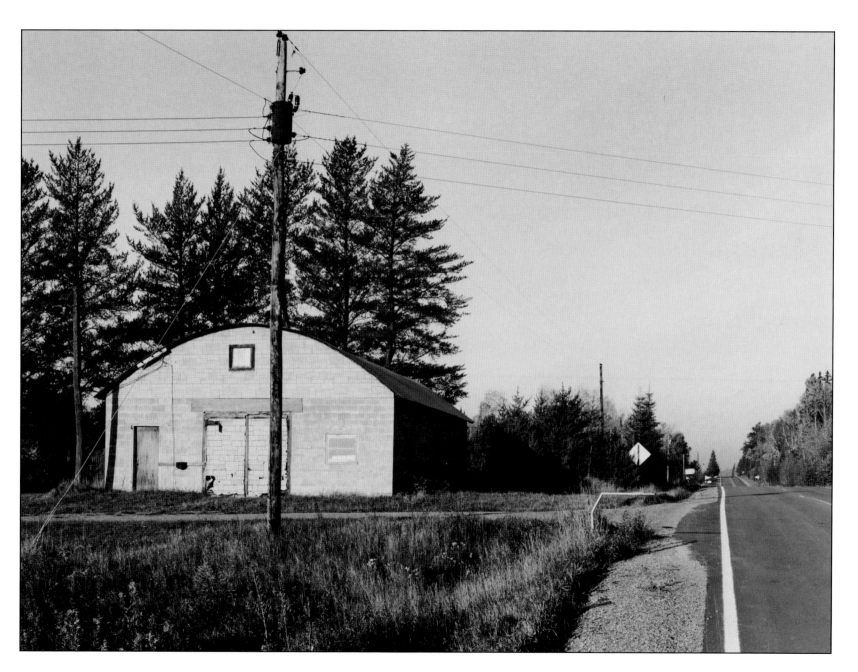

Passing the entrance to the Lehto farm on Lehto Road

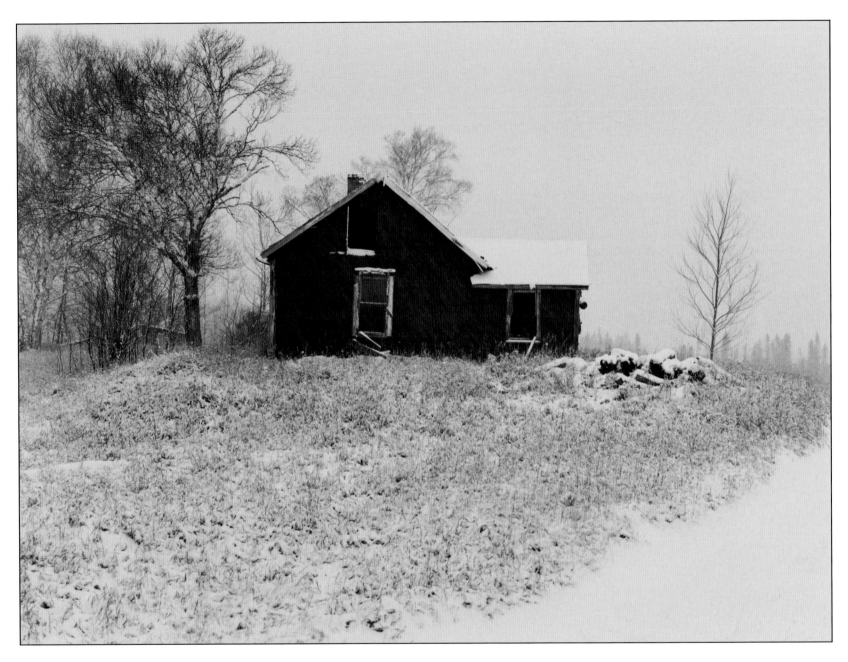

The C. Mattson log house, including a frame addition that shelters the entrance

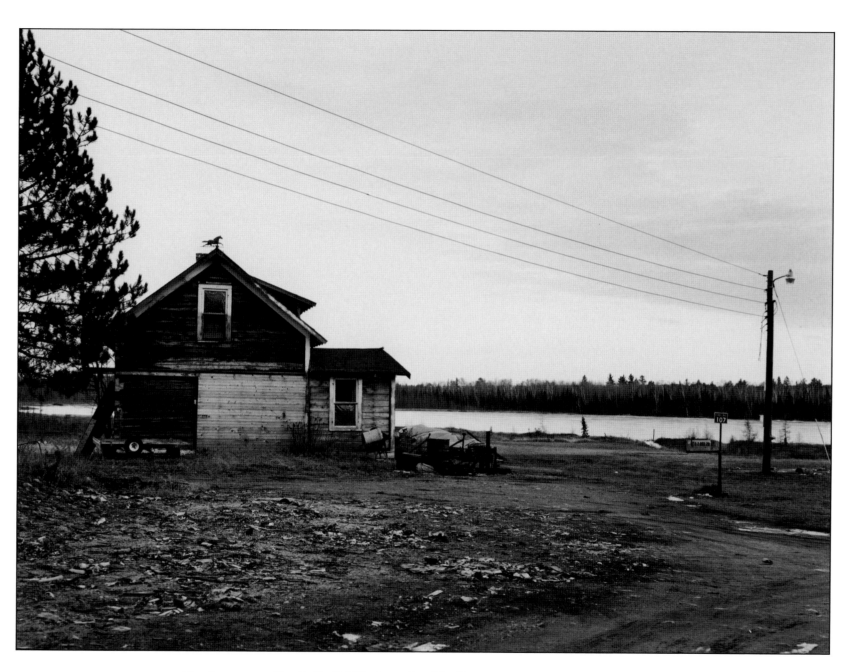

The house on the E. Heikkilla farm beside Heikkilla Lake, Waasa Township

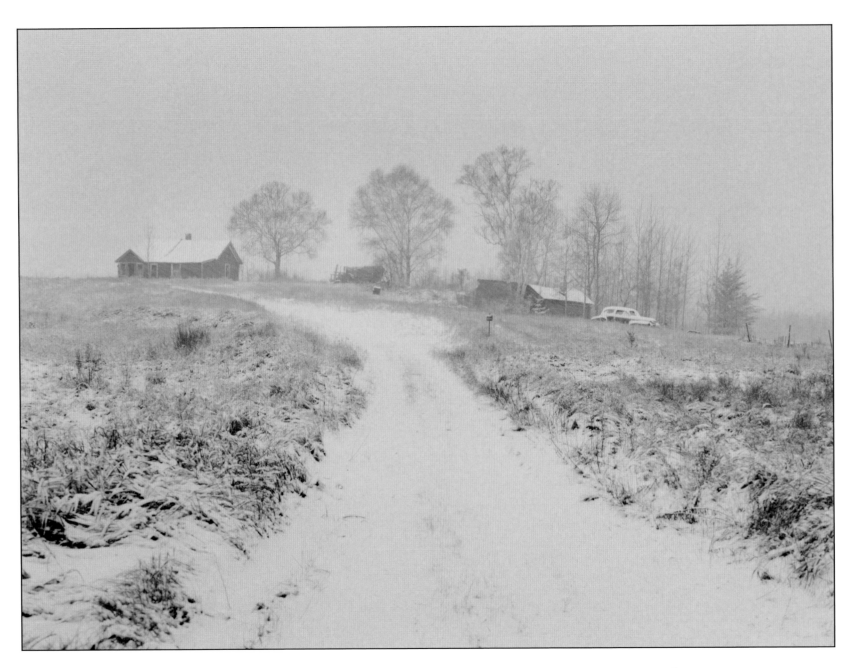

The farmstead of C. Mattson, including the house, a shed, and the *savusauna* or smoke sauna

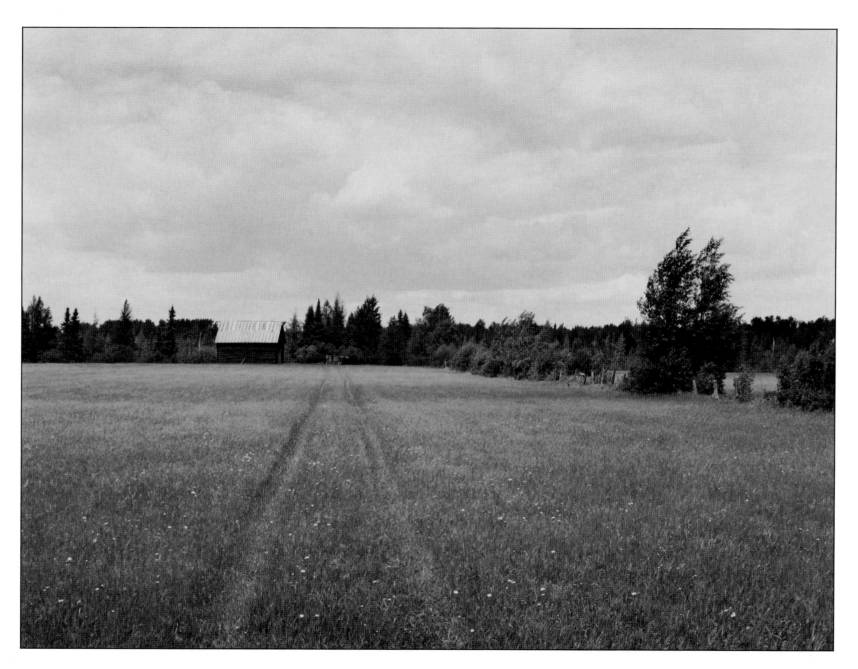

A lato or field hay barn built by Waino Tanttari at the edge of a clearing in Waasa Township

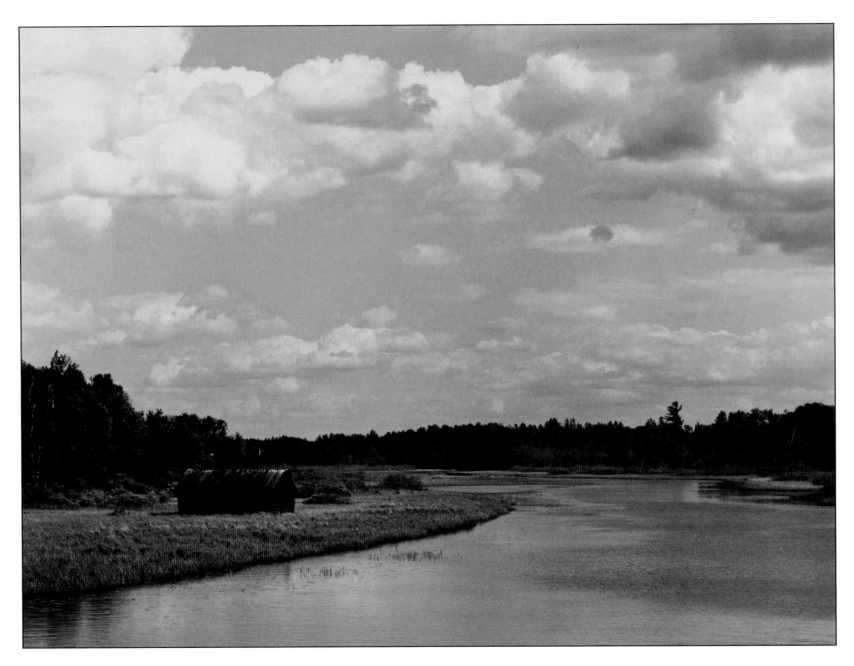

A field hay barn next to the Pike River on the farm of Andrew and Hedvig Saari, Pike Township

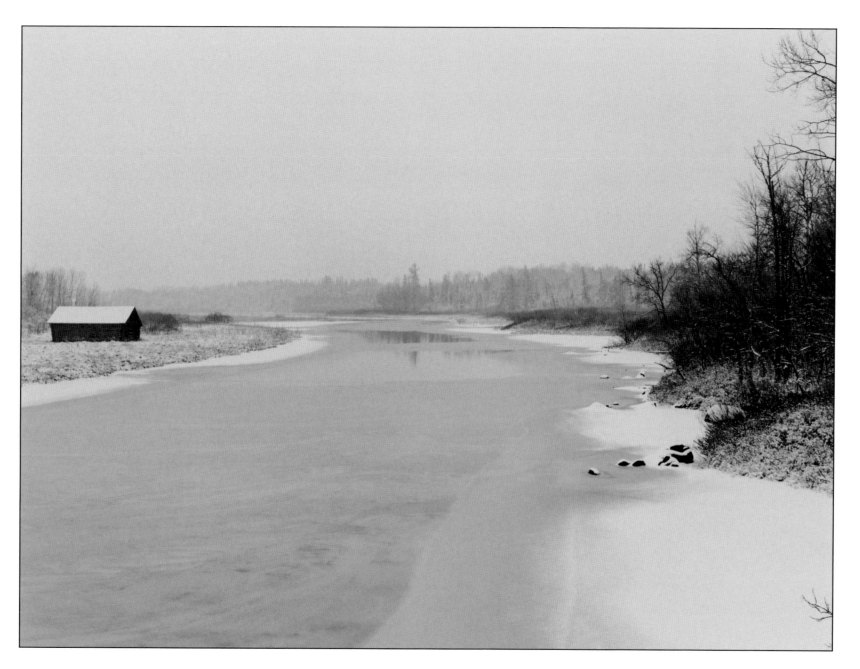

The same view in winter

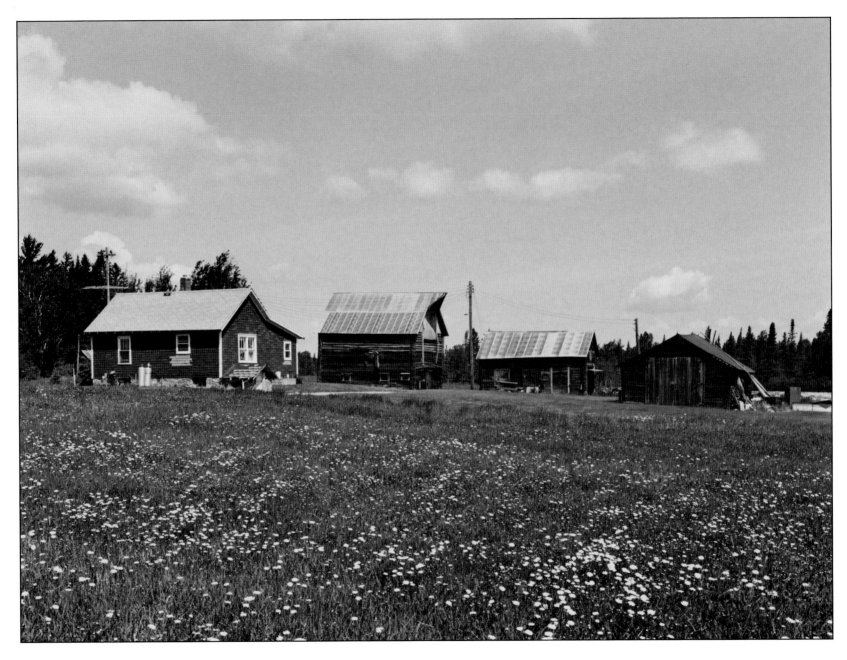

50 The Mike and Mary Matson farmstead, including a house, *navetta* or cattle barn, *talli* or horse stable, and combination cattle and hay barn

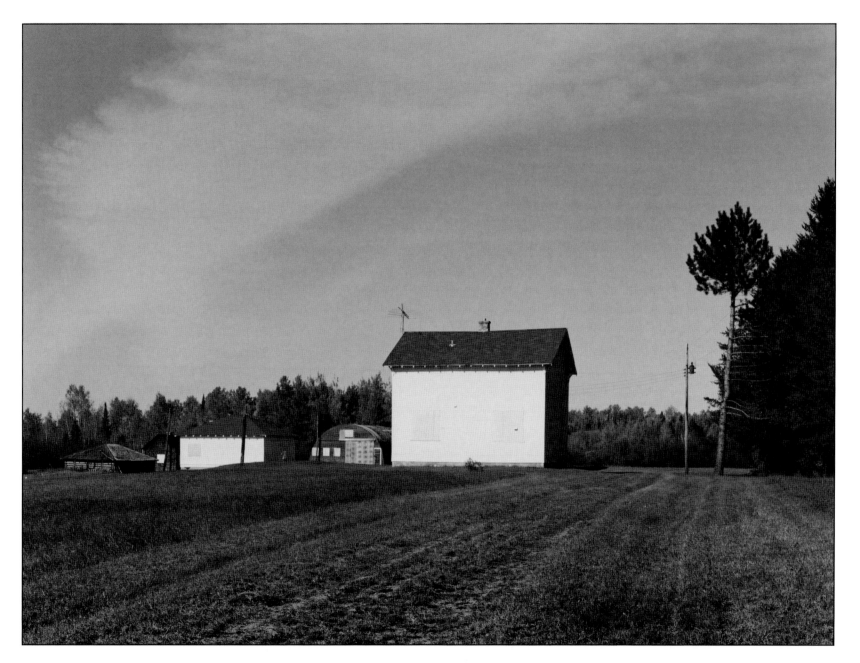

A mixture of traditional log and modern buildings on a farmstead in Embarrass Township

51

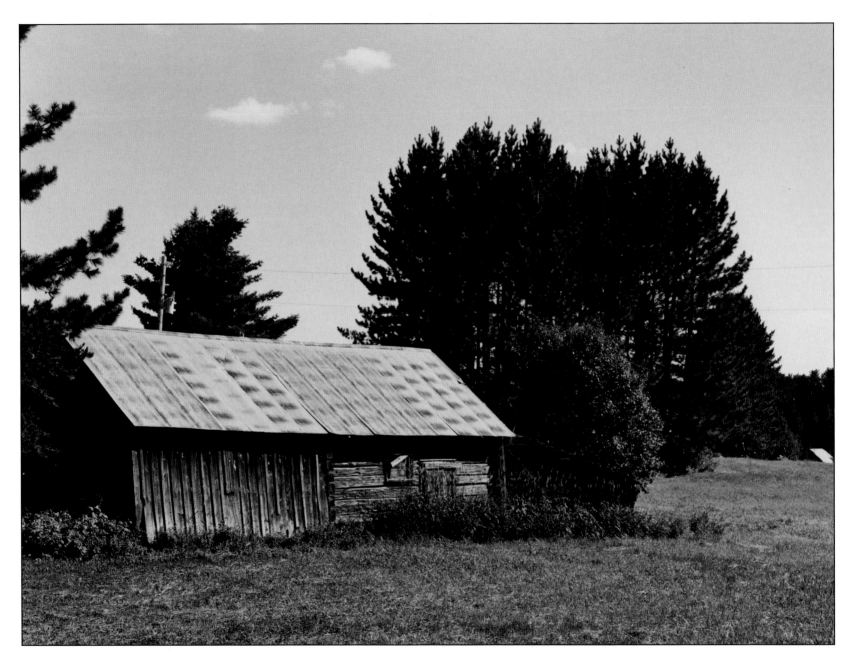

A horse stable on the farm of John and Hilma Makkyla in Waasa Township, with a glimpse of a field hay barn in the distance

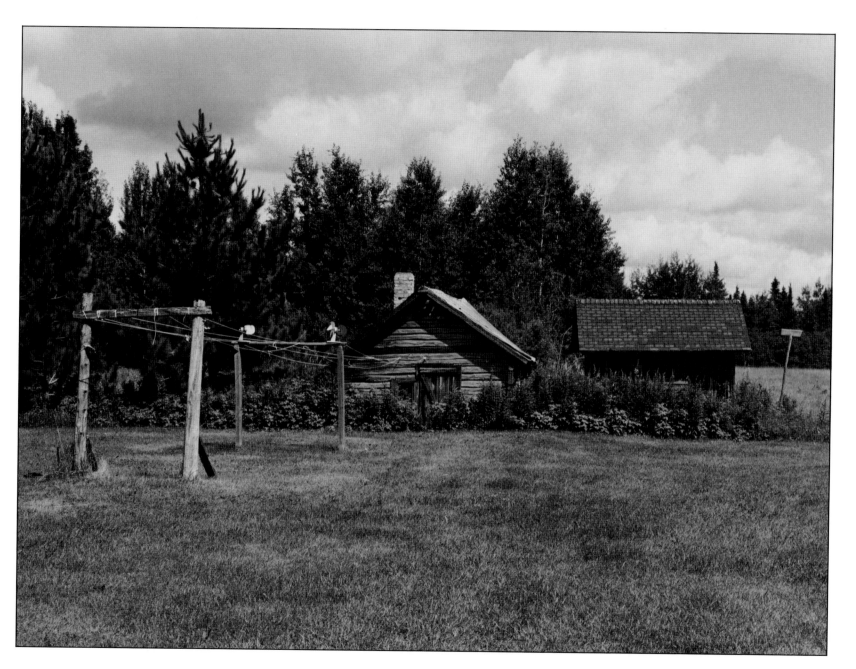

A smoke sauna (left) and *kaymala* or privy on the farm of Gregorius and Mary Hanka

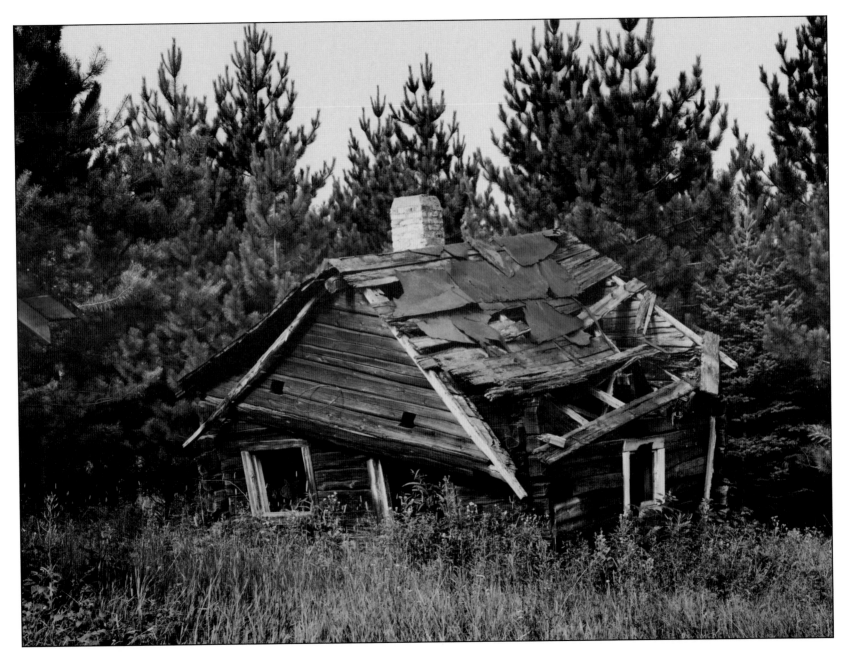

A deteriorating sauna on the farm of Matt and Sophia Niemitala in Waasa Township

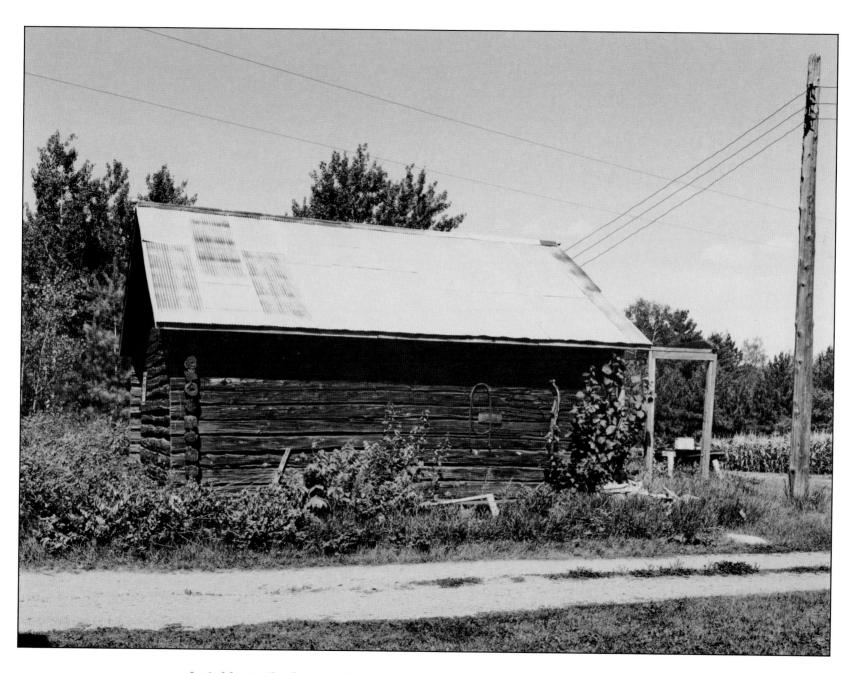

A stable on the farm of August and Johanna Sarvisto in Waasa Township

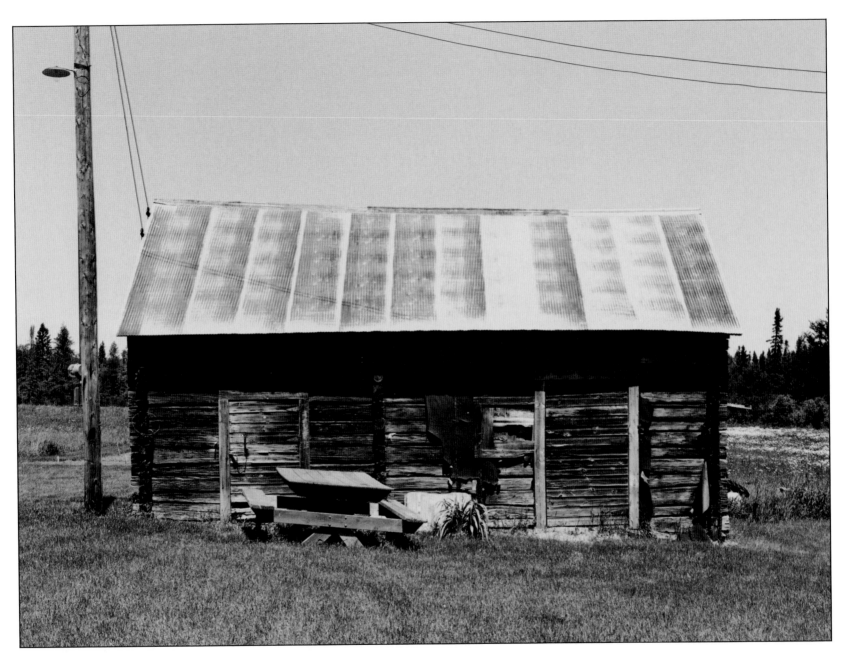

A stable on the farm of Mike and Mary Matson

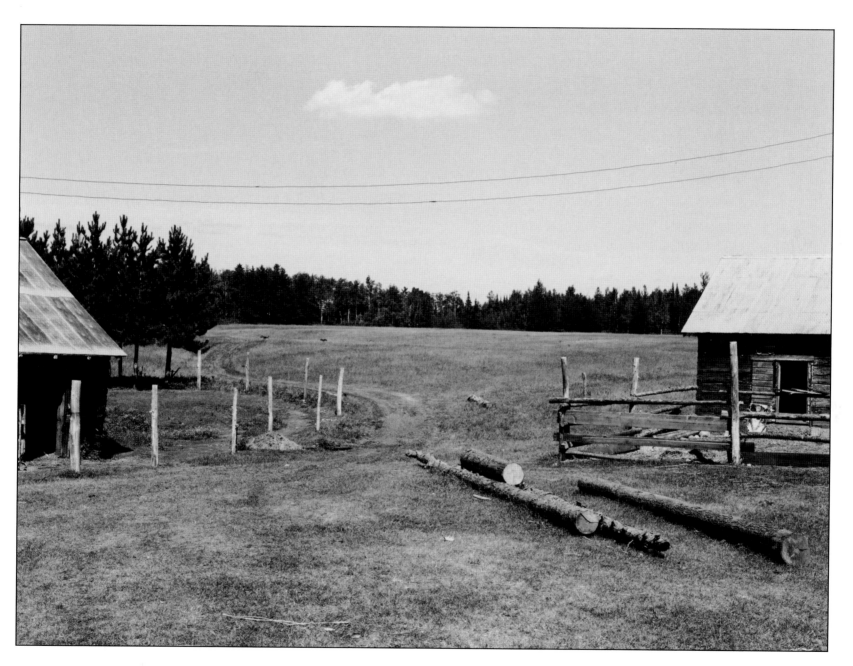

Two animal barns adjoining cleared land on the farm of Elias and Liisi Aho in Waasa Township

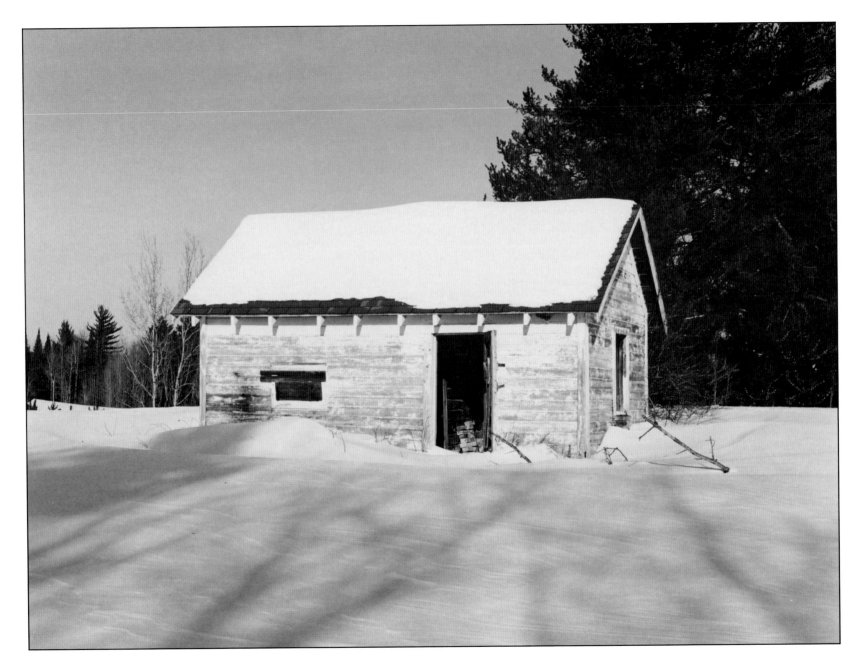

A sauna on the farm of Matt and Emma Hill in Pike Township

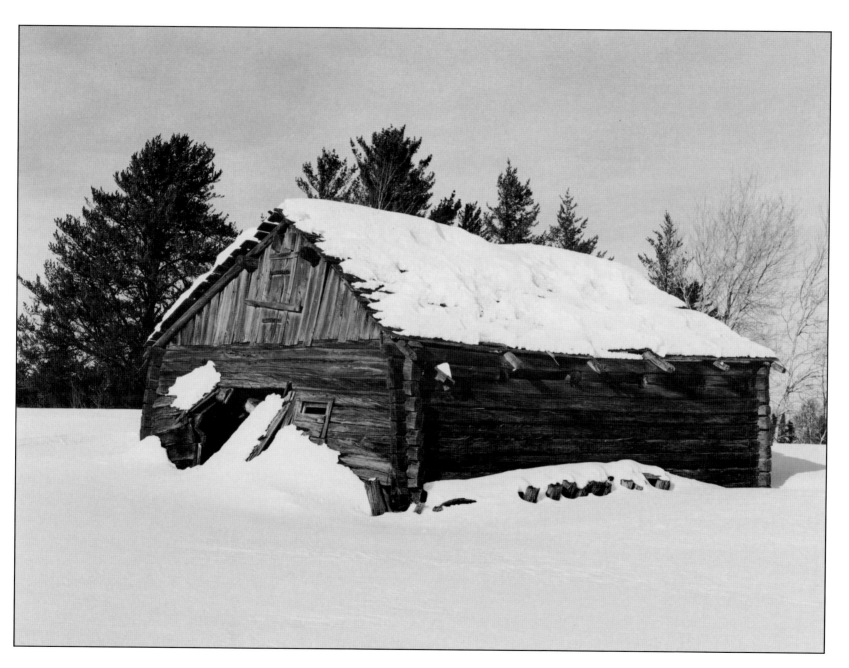

A cattle barn on the Hill farm

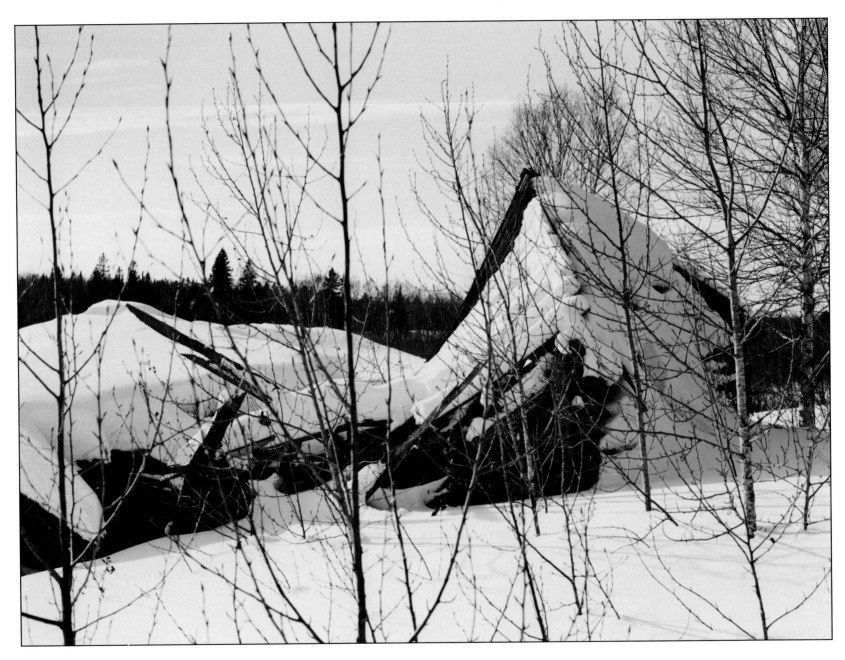

An abandoned log barn on the Hill farm

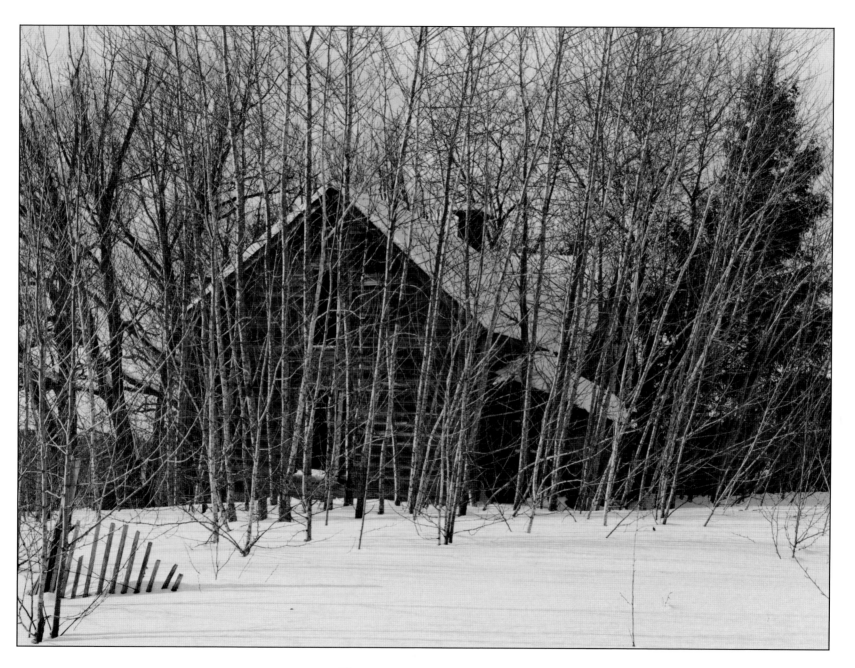

The house on the Hill farm

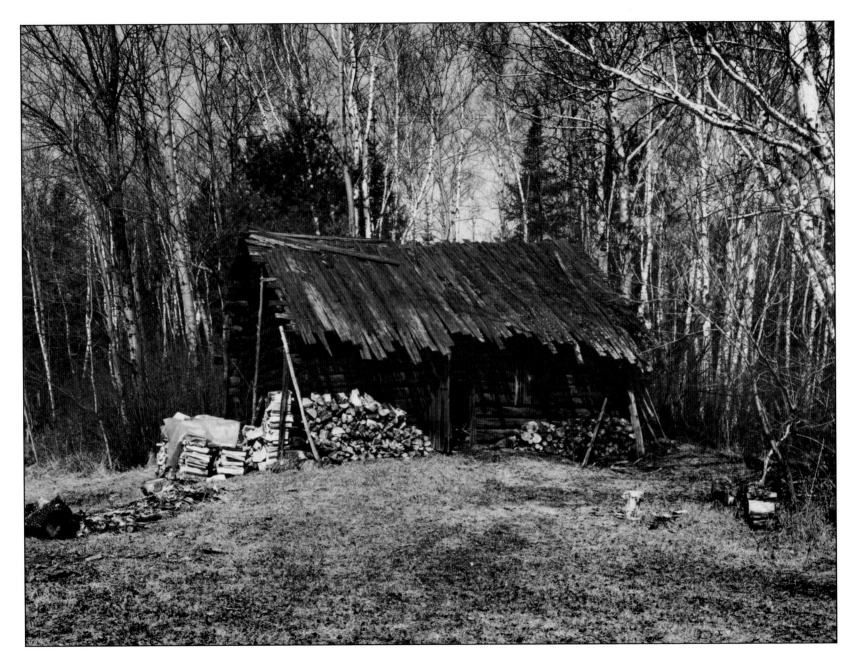

A *puusuoja* or woodshed built by Mikko Pyhala

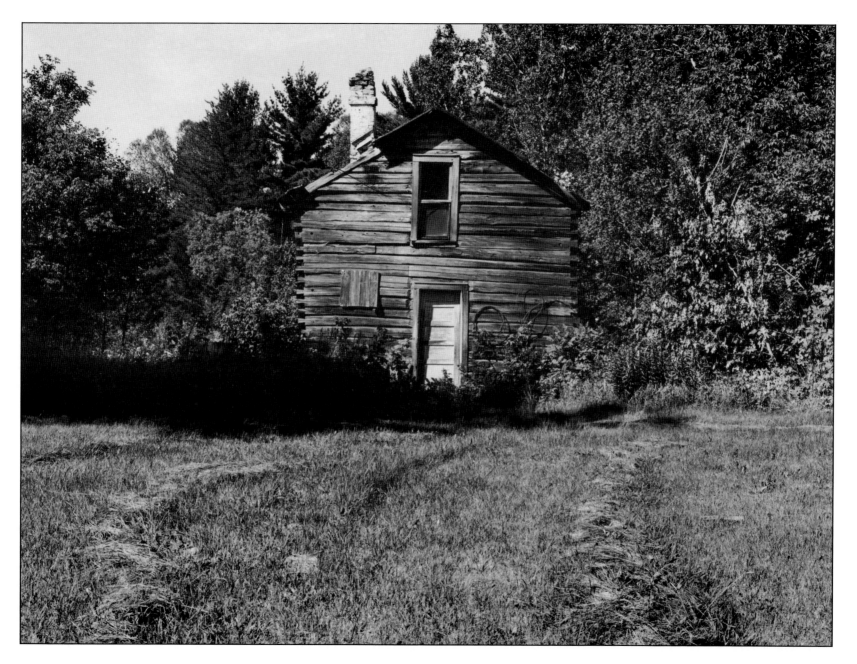

The house on the farm of Mikko and Anna Pyhala

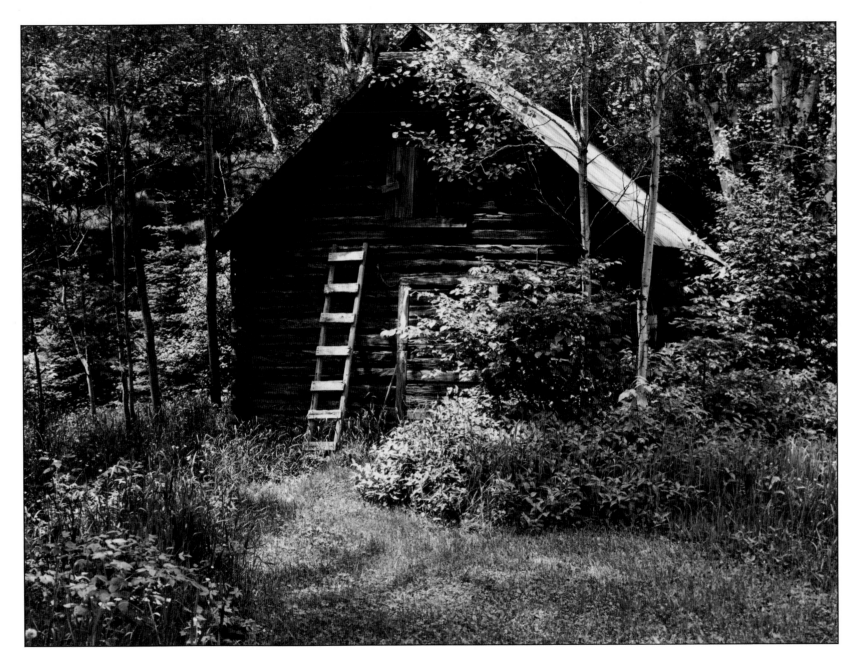

The smoke sauna on the Pyhala farm

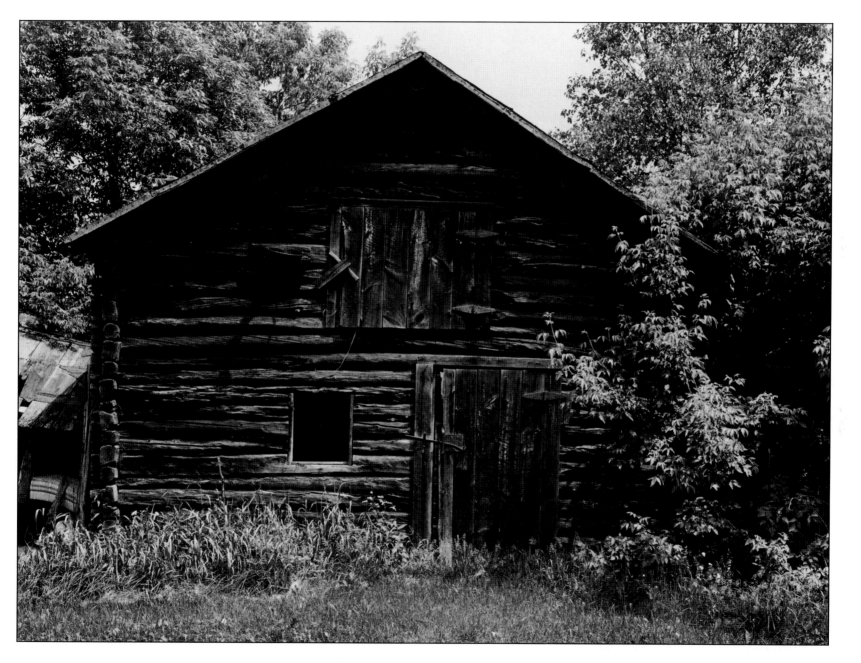

A stable on the Pyhala farm

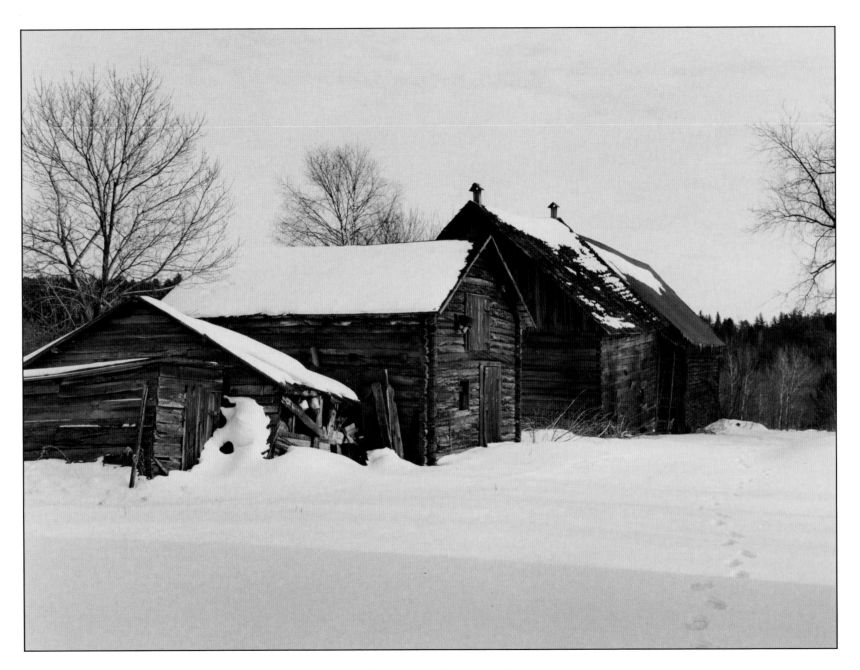

A row of farm buildings lining one side of the Pyhala farm courtyard

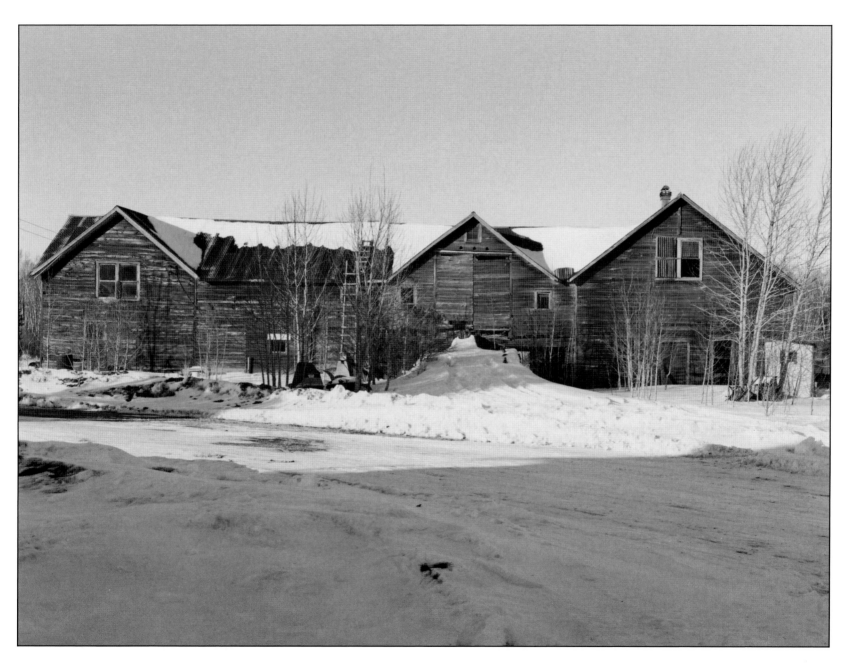

A rare housebarn built by Alex Seitaniemi in Waasa Township to shelter people, livestock, and crops under a common roof 67

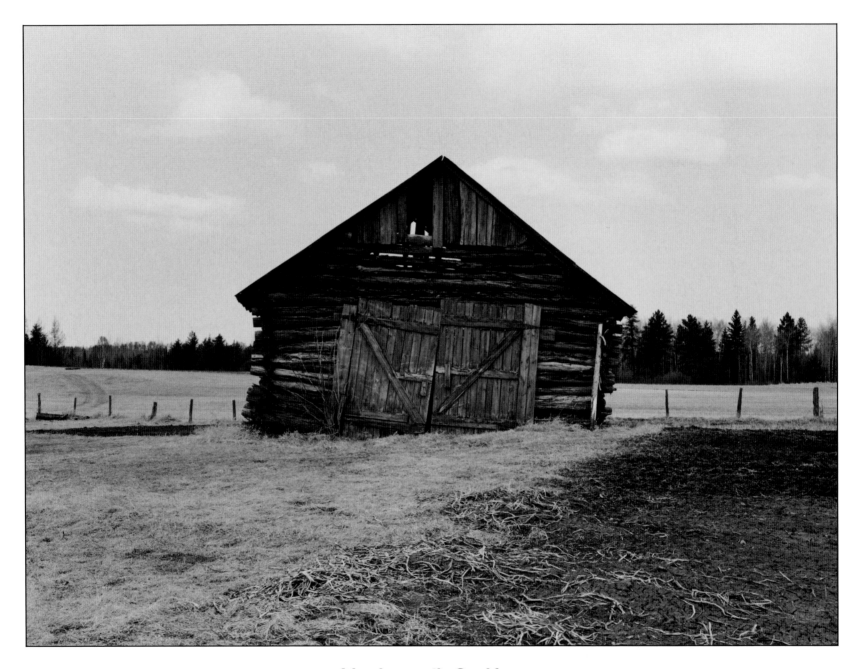

A hay barn on the Saari farm

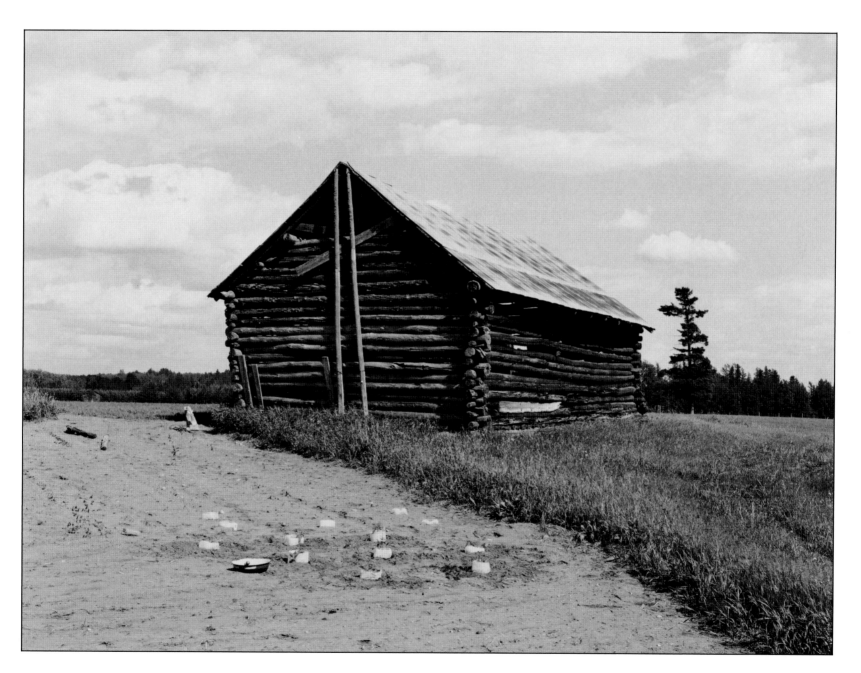

A vegetable garden and rear view of the Saari hay barn

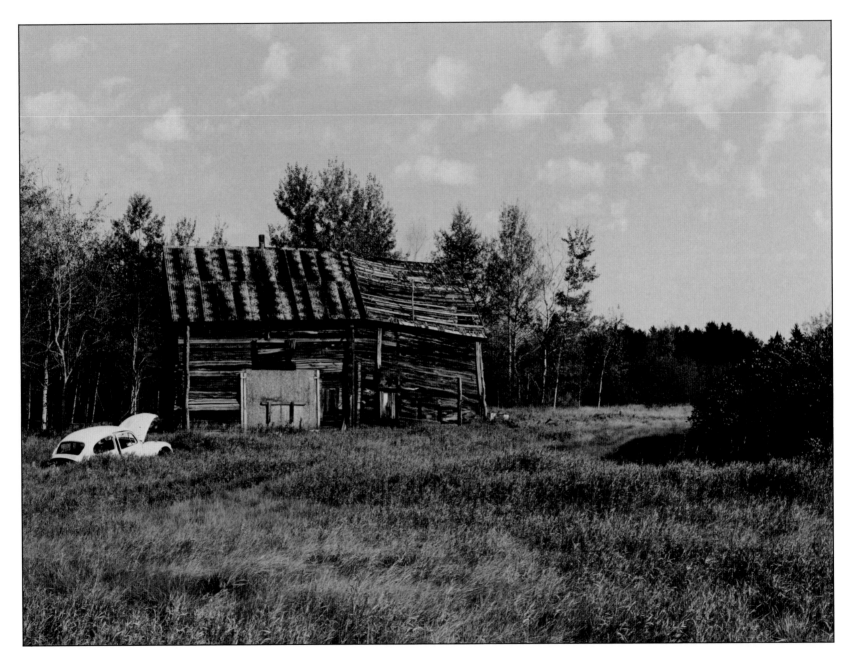

An abandoned cattle barn in Pike Township

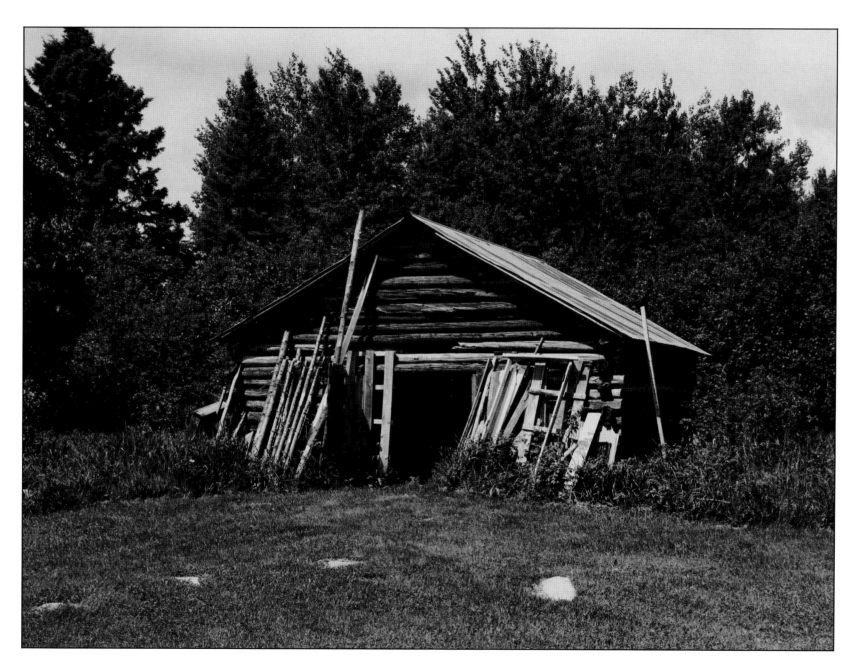

A hay barn on the Matson farm

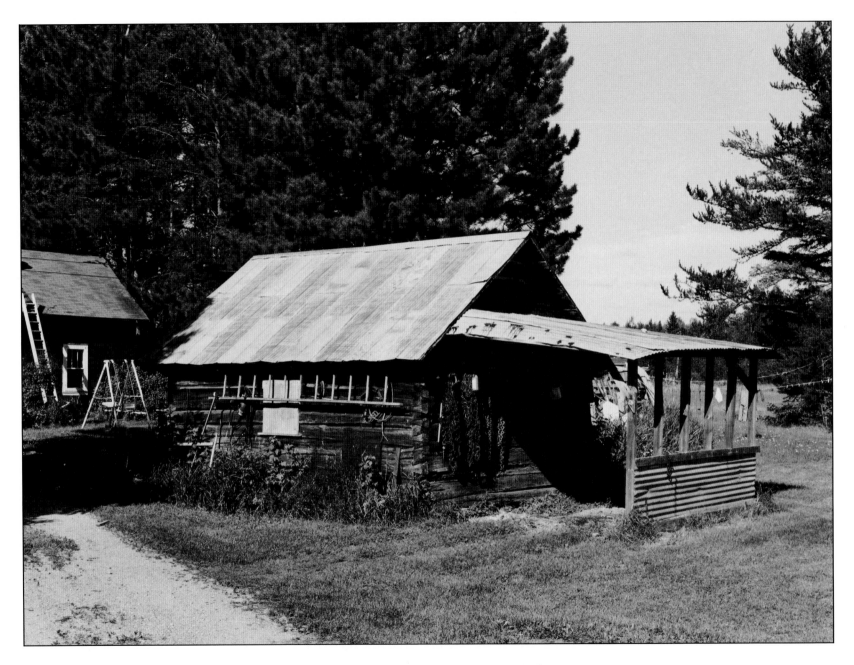

The house and garage on the Makkyla farm

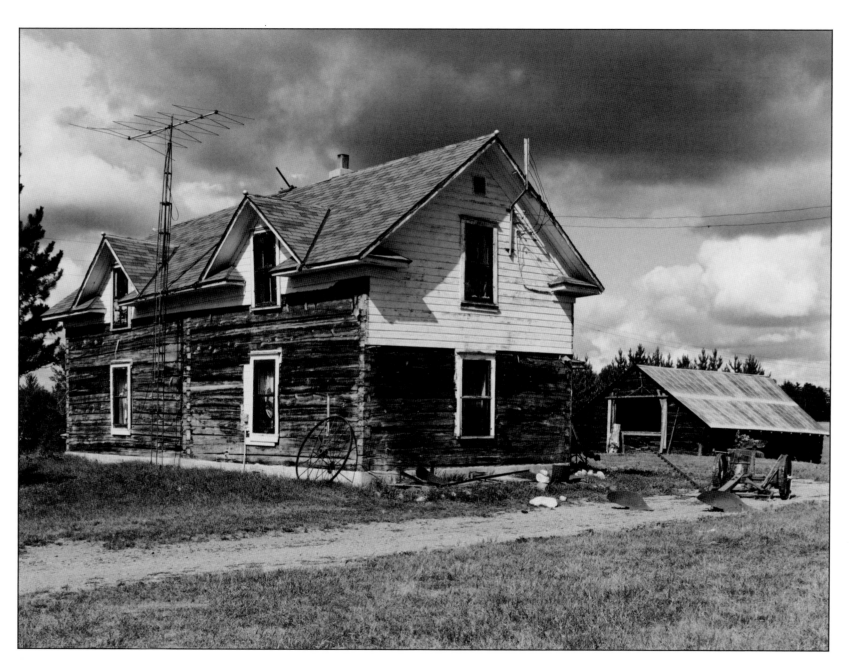

The house and barn on the Aho farm

NOTES ON THE PHOTOGRAPHS

Michael H. Koop

Pages 42–43 Nikolai Lehto emigrated from Vaasa, Finland, around 1907 and found work in the Biwabik Mine several miles southwest of Embarrass. The sale of timber from his 80-acre farm in Embarrass Township enabled him to build the northern half of his house; later he finished the southern half and added an attic. His 1948 sauna replaced an earlier smoke sauna that still survives on the property, along with five other log buildings.

Page 44 Like most Finnish dwellings in the Embarrass area, the C. Mattson house is rectangular in shape with two interior rooms, has one story plus an attic, and is sheathed with clapboards.

Page 45 Heikkila Lake, one of many small bodies of water in Embarrass and adjoining townships, was named for E. Heikkila. Of his original turn-of-the-century farm buildings in western Waasa Township, only the log house remains.

Page 46 This assembly of log buildings includes the three that are most typically found on a Finnish farm in the Midwest: a house, a combination cattle and hay barn (not visible), and a smoke sauna. The sauna (right) is made of hewn timbers with solid double-notch corner joints.

Page 47 Although Waino Tanttari had easy access to his fields in 1935, he chose to continue a centuries-old Finnish tradition by building this freestanding field hay barn to store the hay until wintertime. The barn, which measures about twenty-five feet by thirty-four feet, is built of horizontal logs joined at the corners by saddle notches and spaced a short distance apart to allow circulation of air. Log rafters that are hewn flat on

top and bottom support the metal-clad gable roof. More than fifty years later the barn continued to be used for hay storage.

Pages 48–49 The field hay barns on the Saari farm were constructed in traditional fashion of unhewn timbers with saddle-notched corner joints, a slightly raised floor made of saplings, and walls slanted outward toward the roof to accelerate the drying of hay. The Saari buildings exhibit a sophisticated knowledge of log construction techniques and a high standard of craftsmanship.

Page 50 Five of the original six log buildings remain on the Matson farm. The large cattle barn, built in two stages using unhewn poplar on top of hewn tamarack logs, was constructed soon after the diminutive combination cattle and hay barn (right). A wood frame house replaced the original log dwelling built by neighbor Gregorius Hanka and destroyed by fire. Finnish immigrant Mike Matson moved to Embarrass Township from nearby Virginia, Minnesota, and filed for a 160-acre homestead in 1900. His wife Mary and their children arrived from Finland a year later. By 1906 the family had cleared an impressive 19 acres of land, 13 of which

were plowed, fenced, and planted in hay and vegetables. The farm, which supported eight cattle and one horse, was assessed at one thousand dollars in that year, the highest value placed on any Finnish farm in the area.

Page 51 The buildings at the edge of this cleared land include (from left) a woodshed, hay barn, garage, modern barn, and house.

Page 52 Built in about 1911, this stable is made of hewn, double-notched logs and vertical planks. The hay barn in the distance has an unusual roof system made entirely of unhewn purlins (horizontal units that stabilize the roof). John Makkyla entered the United States in 1896 and found work at the Sparta Mine on the Mesabi Range. In 1907 he applied for a 40-acre homestead in eastern Waasa Township; by the time he obtained his final proof six years later, his wife Hilma and son Matti had joined him on the farm.

Page 53 This smoke sauna is one of six log buildings that originally stood on the farm of Gregorius and Mary Hanka. The other log buildings remaining include a house, a combination cattle and hay barn, and a field hay barn. The interior

of the sauna, which measures about twelve feet by twenty-three feet, is divided into two rooms by a hewn log partition. Like many Finnish settlers in Embarrass, Gregorius Hanka emigrated to America from the province of Vaasa, Finland. He worked at a sawmill in Winton, in iron mines at Ely, and eventually as a logger. In 1910 he and his wife Mary bought an 80-acre parcel of land from the Duluth and Iron Range Railroad. The broadax that Gregorius used to make the log buildings is still kept on the farm, which is owned by the Hankas' son.

Page 54 The construction method used for the Niemitala sauna was typical of that used for other Finnish saunas around Embarrass. The building had rather small, hewn timbers joined by double-notched corner joints, logs up to the ridge in each gable end, one low door, and two windows.

Page 55 August Sarvisto built this eighteen-foot-square stable around 1901 on the 160-acre homestead that he and his wife Johanna farmed in Waasa Township. He secured the square-hewn timbers with double-notch corner joints to create extremely tight-fitting walls.

Page 56 The Matson horse stable, with its smoothly hewn timbers, chinkless walls, and sturdy double corner notches, beautifully illustrates northern European construction techniques. The nineteen-foot-square building was constructed in about 1900.

Page 57 These barns, one with double notching and the other with full dovetail corners, are among the five log buildings constructed on the farm of Elias and Liisi Aho between 1902 and 1907. Elias Aho left the mining town of Sparta and settled on this land in 1901, but a lack of roads prevented Liisi, who suffered from poor health, from joining him on the farm until 1905. By the time the homestead claim was "proved up" in 1907, the family had cleared 16 acres of land.

Page 58 This log and wood-frame sauna has been part of the Matt and Emma Hill farm since 1920, when it replaced an earlier smoke sauna. Measuring about ten feet by eighteen feet, the building is divided into a bathing room made of hewn logs that are joined at the corners with dovetail notches and a changing room framed with two-inch-by-four-inch studs. The exterior is sheathed with drop siding.

Page 59 This nearly square cattle barn (about twenty-four feet on a side) is one story high with a loft. An unusual feature, not visible here, is a vertical pier foundation beneath the log walls. Wagon doors pierce both gable ends of the building, which houses at least eight animal stalls.

Page 60 This deteriorated barn was divided into two pens by a log partition and had walls made of unhewn logs secured at the corners with saddle notches. It is one of six log buildings on the Hill farm.

Page 61 Second-growth aspen trees growing around the Hill house have replaced larger pines that were cleared when the property was homesteaded in the late 1890s. The two-room dwelling, which overlooks the Pike River, measures nineteen feet by twenty-nine feet and is covered with drop siding and boxed corners that conceal tightly fitted hewn logs locked with double notches.

Page 62 The woodshed on the farm of Mikko and Anna Pyhala has unhewn saddle-notched walls that have been reinforced with dowels. Like many Finnish log buildings, it is framed with a ridgepole and unhewn purlins to form a gable

roof; long planks act as roof boards in a technique dating back to ancient Europe.

Page 63 The Pyhala dwelling, measuring seventeen feet by twenty-five feet, was erected in the late 1890s. In traditional Finnish fashion, the builder joined the walls with full dovetail corner notches and constructed a small cellar under the kitchen. Less common features are the gable entrance and the lack of an interior partition. The first floor, a single room, was divided with a curtain to provide some measure of privacy for Mikko, Anna, and their seventeen children.

Page 64 A small door in the gable end leads inside the Pyhala two-room smoke sauna, which was built in 1924. Blackened walls in the bathing chamber indicate years of heating the room in the traditional manner, and two small wooden vents in the ceiling and back wall show how its users regulated the temperature and released smoke to the outside.

Page 65 The Pyhala family sheltered two horses and a pony in this stable, which was built in 1929. The building measures about seventeen feet by nineteen feet and has tightly fitted log walls from the sill to the ridgepole. The walls are fur-

ther secured by double corner notches and are reinforced at the door with wooden dowels.

Page 66 This building ensemble – from the right, the cattle barn with attached hay barn, the stable, the shed, and the privy – forms one side of a courtyard that caters to the agricultural activities on the Pyhala farm. Hayfields lie out of view on the left. Facing this ensemble across the driveway are the buildings and spaces oriented toward the family's domestic needs: the house, sauna, woodshed, vegetable garden, and well.

Page 67 This distinctive housebarn, which is over ninety feet long, was built by Alex Seitaniemi in two phases between about 1907 and 1913. Seitaniemi, an immigrant from Sodankylä in northern Finland, worked for the Tower Lumber Company, which sold him his 80-acre parcel of land. He constructed the original two-story homestead (left) of hewn tamarack logs joined at the corners by full dovetail notches. Large unpartitioned rooms on the main floor and upstairs provided living space for the five members of the Seitaniemi family, while horses and cattle were kept in an adjoining section.

Seitaniemi later built the two-bay ad-

dition. Earth ramps on both the north and south sides of the first bay lead to a hayloft near the center of the barn. The second bay, extending beyond the width of the rest of the building to form an L, is a cattle barn built of poplar and tamarack logs. As in the rest of this finely crafted housebarn, the hewn logs are joined at the corners by full dovetail notches.

Pages 68–69 The gaps between the unhewn logs of this Saari field hay barn, which measures about twenty feet by twenty-three feet, help to circulate air through the hay that is stored within.

Page 70 Log cattle barns are becoming obsolete in the Embarrass area as they are replaced by larger buildings made of modern materials.

Page 71 Unhewn balsam, spruce, and tamarack timber – three kinds of wood customarily used by Embarrass area Finns – was taken from the vicinity to build this nineteen-foot-square Matson hay barn in the early 1900s.

Page 72 John and Hilma Makkyla's sons built the log house in the background to replace the original dwelling in 1935 and added the log garage at the same time.

Page 73 In the fall of 1901 a neighbor reported that Elias Aho was constructing a "big house," which was probably sheathed with drop siding soon thereafter. Nine decades later the owners of the house were removing this siding to expose the square-hewn, chinkless log walls that are joined with full dovetail corner notches. The building in the background is an animal barn.

BIBLIOGRAPHY

Alanen, Arnold R. "In Search of the Pioneer Finnish Homesteader in America." *Finnish Americana* 4 (1981): 72–92.

———. "Years of Change on the Iron Range." In *Minnesota in a Century of Change: The State and Its People Since 1900*, edited by Clifford E. Clark, Jr., 155–94. St. Paul: Minnesota Historical Society Press, 1989.

Alanen, Arnold R., and William H. Tishler. "Finnish Farmstead Organization in Old and New World Settings." *Journal of Cultural Geography* 1 (Fall/Winter 1980): 66–81.

Berman, Hyman. "Education for Work and Labor Solidarity: The Immigrant Miners and Radicalism on the Mesabi Range," 1963. Unpublished manuscript. Available on microfilm at the Minnesota Historical Society, St. Paul.

Betten, Neil. "Riot, Revolution, Repression in the Iron Range Strike of 1916." *Minnesota History* 41 (Summer 1968): 82–94.

———. "Strike on the Mesabi – 1907." *Minnesota History* 40 (Fall 1967): 340–47.

Eleff, Robert M. "The 1916 Minnesota Miners' Strike against U.S. Steel." *Minnesota History* 51 (Summer 1988): 63–74.

Hoglund, A. William. *Finnish Immigrants in America, 1880–1920*. Madison: University of Wisconsin Press, 1960.

———. "Flight from Industry: Finns and Farming in America." *Finnish Americana* 1 (1978): 1–21.

Jalkanen, Ralph J., ed. *The Finns in North America: A Social Symposium*. Hancock: Michigan State University Press for Suomi College, 1969.

Jordan, Terry G., and Matti E. Kaups. *The American Backwoods Frontier: An Ethnic and Ecological Interpretation*. Baltimore: Johns Hopkins University Press, 1989.

Karni, Michael G., ed. *Finnish Diaspora II: United States*. Toronto: Multicultural History Society of Ontario, 1981.

Karni, Michael G., Matti E. Kaups, and Douglas J. Ollila, Jr., eds. *The Finnish Experience in the Western Great Lakes Region: New Perspectives*. Turku, Finland: Institute for Migration, 1975.

Karni, Michael G., Olavi Koivukangas, and Edward W. Laine, eds. *Finns in North America: Proceedings of Finn Forum III*. Turku, Finland: Institute for Migration, 1988.

Karni, Michael G., and Douglas J. Ollila, Jr., eds. *For the Common Good: Finnish Immigrants and the Radical Response to Industrial America*. Superior, Wis.: Tyomies Society, 1977.

Kaups, Matti E. "Finnish Log Houses in the Upper Middle West: 1890–1920." *Journal of Cultural Geography* 3 (Spring/Summer 1983): 2–26.

———. "Finnish Meadow–Hay Barns in the Lake Superior Region." *Journal of Cultural Geography* 10 (Fall/Winter 1989): 1–18.

———. "A Finnish Savusauna in Minnesota." *Minnesota History* 45 (Spring 1976): 11–20.

———. "Log Architecture in America: European Antecedents in a Finnish Context." *Journal of Cultural Geography* 2 (Fall/Winter 1981): 131–53.

Kivisto, Peter. *Immigrant Socialists in the United States: The Case of Finns and the Left*. Rutherford, N.J.: Fairleigh Dickinson University Press, 1984.

Kolehmainen, John I. "The Finnish Pioneers in Minnesota." *Minnesota History* 25 (December 1944): 317–28.

Koop, Michael H. National Register of Historic Places registration forms for individual properties in Embarrass, Pike, and Waasa townships, St. Louis County, 1988–89. National Park Service, U.S. Department of the Interior. Available at State Historic Preservation Office, Minnesota Historical Society.

———. "Rural Finnish Log Buildings of St. Louis County, Minnesota, 1890–1930." Multiple Property Documentation Form, 1988. National Park Service, U.S. Department of the Interior. Available at State Historic Preservation Office, Minnesota Historical Society.

Lamppa, Leonard. "The History of Embarrass." *Aurora Journal* (Aurora, Minn.), Aug. 25, 1955, p. 1, 5.

Lamppa, Richard. "History of Embarrass Township," 1966. Unpublished manuscript. Photocopy available at the Minnesota Historical Society.

Minnesota. Secretary of State. Manuscript census schedules for Township 60 Range 15 (Embarrass), Township 60 Range 14 (Waasa), and Pike Township, St. Louis County, 1905.

Norha, Eino M. "History of Embarrass Township," 1960. Translated by Vera Parin, Esther Norha, and Toivo Waisanen, 1980. Unpublished manuscript.

Photocopy available at the Minnesota Historical Society.

Riipa, Timo. "The Finns and Swede-Finns." In *They Chose Minnesota: A Survey of the State's Ethnic Groups*, edited by June Drenning Holmquist, 296–322. St. Paul: Minnesota Historical Society Press, 1981.

Ross, Carl, and Marianne Wargelin Brown, eds. *Women Who Dared: The History of Finnish American Women*. St. Paul: Immigration History Research Center, University of Minnesota, 1986.

U.S. Census Bureau. Manuscript census schedules for Township 60 Range 15 (Embarrass), St. Louis County, Minnesota, 1900.

——. Manuscript census schedules for Embarrass and Pike townships, St. Louis County, Minnesota, 1910.

Wasastjerna, Hans R., ed. *History of the Finns in Minnesota*. Translated by Toivo Rosvall. Duluth, Minn.: Minnesota Finnish-American Historical Society, 1957.